MARILYN

© 2002 Assouline Publishing, first English edition
601 West 26th Street, 18th floor
New York, NY 10001, USA
Tel.: 212 989-6810 Fax: 212 647-0005
www.assouline.com

First published by Editions Assouline, Paris, France

Translated from the French by Uniontrad
Color separation: Gravor (Switzerland)
Printed in China
ISBN: 2 84323 395 X
10 9 8 7 6 5 4 3 2
All photos Milton H. Greene and UPI:
© 1999 The Archives of Milton H. Greene, LLC.
All rights reserved. www.archivesmbg.com 541-997-4970.

MARILYN

JEAN-JACQUES NAUDET

ASSOULINE

henri Cartier-Bresson loves telling one of his most memorable photographic anecdotes, about Marilyn Monroe: the year was 1960 on the set of *The Misfits*, directed by John Huston. He got to Reno in the afternoon, and was invited to a large dinner organized by the production team. He was seated next to Marilyn. The star was running late and Henri put his Leica on her chair. Forty-five minutes later, Marilyn arrived, said hello to everyone, and was disconcerted to see that her chair was "taken." Henri didn't move. She remained standing a few minutes; she didn't know what to do. Finally she asked if he'd take his camera away. "No," quipped Cartier-Bresson, "not before you give it your blessing." She understood immediately, and posed, for a quarter of a second . . . with her derrière on Henri's Leica.

She was born Norma Jean Baker, on June 1, 1926. Her mother was a film editor but had to be institutionalized when Norma Jean was still a little girl. She never knew her father. Raised by a series of adoptive parents, she also spent two years in an orphanage. All the

ingredients were there: neurosis, depression, fear, relentless determination to be a mother, instability . . . everything needed to make a modern tragedy. At sixteen, her final adoptive mother married her off to a neighbor, Jim Dougherty. The war broke out and he was called to serve in the merchant navy. Marilyn found work in a factory in Burbank, California. She spent her time there inspecting parachutes. It was there that, in 1944, she met her first photographer, David Conover. He was on assignment for the American army and wanted to show off the courage of young American women working to support the war effort. "Can I take your picture? You're wonderful. With these pictures, we're really going to raise the morale of our troops." The photos were published in *Stars and Stripes*.

Just two weeks later, a friend of Conover's named Potter Hueth called up Marilyn: "I'd like to take some pictures of you. If any of the photos are bought by magazines, I'll give you five dollars a picture." Marilyn posed at night and continued working during the day. She was soon sought out by Emmeline Snively, the director of the Blue Book Agency. "You've got what it takes to become a model, but you'll have to take modeling lessons. It costs one hundred dollars." Marilyn was forced to admit she had no money. "Don't worry about that, I'll find work for you." That's when André de Dienes, a thirty-two year old Hungarian photographer, entered her life. They had a brief affair in 1945; his memoirs tell the story: "The first thing I did when I got to Hollywood was phone up a specialized agency. I wanted a model who would be willing to pose in the nude. I could feel there was some hesitation. At the

agency, there was a young woman with no experience but who was eager to start. Perhaps she would accept my conditions . . . she was sent to me. An hour later she rang at my door: tight-fitting pink sweater, curly hair held back in a pink ribbon . . . a hatbox in hand. She seemed intimidated. She had a youthful smile, a steady gaze. She was attractive. I'd had years of experience, I knew how to judge a woman's beauty, her sparkle, her style, whether she was photogenic. I didn't need to undress her to know how she was built. At first glance, she wasn't at all what I was looking for: she was too naïve, too awkward. Perhaps right for silly, sentimental postcards, posing with a bouquet of flowers, or a cat. However, I knew just how much I could get out of this face still childish, this body round yet graceful, this diamond in the rough. 'My name is Norma Jean Baker,' she said to me. She was wearing a wedding ring, which seemed ridiculous. She did not look like she was nineteen-years-old. But she had been married, for three years, to a guy named Dougherty, who traveled the oceans. Their divorce was pending. She accepted my usual price without hesitation: one hundred dollars per week, and I handled all expenses, traveling and food, if we went beyond my studio. She was ready immediately, we could start the following day."

A few months later, they traveled through California, Arizona, Nevada and Oregon. De Dienes got his best photos of Marilyn there. One night, she became his: "The hotel was old-fashioned but charming. Dinner was excellent. The room was mediocre and in the bathroom there was only a shower. We flipped to see who went first, and she won. Under the shower, I could hear her humming. She slipped silently into the big bed where I joined her. It seemed like the most natural thing in the world. The night was ours. Between us was the familiarity borne of our trip; we felt no embarrassment. In my head, I already knew her body, and I was

7

overwhelmed to discover it in reality. All she felt for me, trust, gratitude, admiration maybe, melted into the way she expressed herself to me physically. It was all very simple, beautiful, between us. Why did we wait so long? The sky was with us: waking from a long loving sleep, I saw big snowflakes falling. The roads could no longer be driven on. We were prisoners. We spent the whole day in our room, poking our heads out only briefly when a ray of sunshine came through, to take some photos. The lighting wasn't excellent, at least that was the excuse we used to quickly get back in bed. Norma Jean snuggled up adorably in the wrinkled sheets, then held them up like a screen in front of her naked body, thrashing them about joyously, smoothing them out carefully, like a tablecloth, to eat a piece of toast. I couldn't take my eyes off her, and I recorded all the poses I would ask her to assume the next time I photographed her. The lighting in the room was poor, the flash would have ruined its intimate character. On that day, I was her lover, not a professional. These delicious moments belonged only to us. Letting them go to others would have been a travesty." The romance was short-lived, but they did remain friends. This first photographic journey ended with Marilyn Monroe's first cover appearance for the magazine *Family Circle* in April, 1946.

then another photographer came onto the scene. He went by the name of Bernard of Hollywood. He took Norma Jean under his wing and introduced her to the world of cinema. After an initial test run, she was hired by Fox, but without any results. For three years, the young recruit had to cross a veritable desert which ended only in 1950, after seven minor, forgettable

appearances. In the meantime, in 1948, Norma Jean Baker-Dougherty, divorced, decided to change her name. She became Marilyn Monroe. In 1949, touching bottom, she posed nude for Tom Kelley, a calendar photographer. She was paid 50 dollars . . .

But the photographic fairies were watching over her. Sam Shaw presented her to John Huston who was working on a film, *Asphalt Jungle*. Captivated by her magnetism, Huston immediately hired her, and Marilyn's career was off. The rest is a part of Hollywood history. The only downside to this extraordinary career was a scandalous photograph that nearly cost Marilyn the start of her glorious career. The Western Lithograph Company did indeed come out with a calendar, "Miss Golden Dreams," featuring Tom Kelley's photos. The calendar was considered pornographic, and was banned in two states. But it was a huge commercial success, worth a million dollars in profits. No one had recognized the model until 1952, when her identity was discovered. A scandal broke out. Puritan leagues took offense and Fox was forced to consider breaking her contract. But Marilyn skillfully turned the tables. She said: "Yes, that was me. Yes, I posed. I was hungry. In Hollywood, there are a lot of ways a girl can make fifty dollars without running the risk of being recognized. I think the public knows that." *Life* confirmed her triumph by giving her the cover of the magazine on April 7, 1952. The photographer, Philippe Halsman, would later say: "I believe I was the first one to capture the way Marilyn carries herself. By trying to discover her personality, I revealed her posterior to America."

In 1952, while filming *Niagara*, she became friends with the photographer Jock Carroll. Many never-before-seen photos would be published in 1996. Marilyn was quoted as saying: "I want to be a real actress. I know that makes some people chuckle, but I couldn't care less. People have always made fun of me, so I keep my mouth

shut: but I will be an artist, not an erotic monster. I don't want to be sold to the public as a celluloid aphrodisiac."

Little by little, new fairies came onto the scene. Their names are a part of history: Cecil Beaton, Richard Avedon, and above all, Milton Greene, who played an important role in Marilyn's life. They met in Hollywood at the end of the summer of 1953, when the magazine *Look* sent its best photographers to meet with the latest sex symbol. Over the next four years, he conducted over fifty photo shoots with Marilyn.

Milton convinced the actress to break her contract with Fox so they could create their own, independent production company together: Marilyn Monroe Productions (MMP). They produced *Bus Stop* and *The Prince and the Showgirl*. From time to time, she would even live with Milton's family where she found the security that was beneficial to both her work and her well-being. But their collaboration ended in 1957, when Marilyn's third husband, Arthur Miller, decided to handle his wife's business. Bitter, Milton withdrew from MMP, refusing to let anyone see or publish the photos he took of Marilyn until his death in 1985.

a s her celebrity status grew, Marilyn laid down the law. She became her own director, her own star, her own publisher. She had the power to reject or "kill" any photo she didn't like. And she wielded this power not only on her pictures but also on magazine articles. If a publisher wanted her, he was forced to accept her conditions. Marilyn knew exactly how she wanted to be seen. More photogenic than most could ever dream of being, she loved to have her picture taken. She didn't have to learn any lines like she did for her movies. She could let

her imagination run wild, without having to worry about notions of continuity or plausibility. She could be a different Marilyn for each session or each photo. It was always a party; there was champagne, music . . . but she was always concentrated. She would say: "We're going to do a Marilyn."

Eve Arnold, who had started taking pictures of her around this time, remembers: "Her skin was 'pneumatic,' you could almost touch it on the screen. Moviemakers call it 'flesh impact.' Her skin was translucent, white, luminous. Close up, around her face, light was captivated. It formed an aura, and gave her a luminous quality on film."

When production on the film *The Prince and the Showgirl* started, Cecil Beaton photographed Marilyn for *Harper's Bazaar*. It was a photo she loved, the grain was light, like a color photo turned black and white. In the photo, she looks about sixteen and holds a rose in her hand. Beaton wrote: "Marilyn Monroe reminds us of a fireworks display, her admiring, awe-struck spectators lighting up in a chorus of 'Ohs!' and 'Ahs!' She's as spectacular as the silvery gushes of the Vesuvius fountains; she came from the shadows to become the post-war sex symbol—the pin-up of our time. No matter what the media dazzle or the illusion that lit her flame, it is her genius alone that gave her the wings to fly."

Out of everyone, Richard Avedon is the one who took the series of pictures of her she liked the most. Taken for *Life*, they were an homage to the great pre-war sex symbols: Jean Harlow, Clara Bow, Lillian Russell, Theda Bara and Marlene Dietrich. Simone Signoret wrote about it in her autobiography: "She got a little on my nerves.

It was kind of tiresome to hear her tell about how happy and inspired she felt for the months during which she did these photos with Richard Avedon. The series was really remarkable; they were photos of her personifying the great stars of the 1930s. But listening to her, you'd think that her only satisfying moments as an actress came when she was dressed up as Marlene, Garbo and Harlow. She talked about these photo shoots like an actress would talk about her films. No other professional experiences seemed to have given her so much joy. No laughing fits with friends, no funny stories to tell, no hugging and celebration after a scene where everyone had played well together. That was all foreign to her. I couldn't understand it."

t he filming of *The Misfits* by John Huston, in 1960, a story about cowboys hunting the last wild horses, to be sold for dog food, was one of the most dramatic in Hollywood history. Clark Gable knew he was doomed, and he died a month later. Montgomery Clift, disfigured in an accident, was only a shadow of his old self. And Marilyn Monroe was living out her last days before her divorce from Arthur Miller, who wrote the screenplay. This was the only film exclusively covered by photographers from the Magnum agency . . . and what artists they were! Henri Cartier-Bresson, Ernst Haas, Bruce Davidson, Elliot Erwitt, Cornell Capa, Eve Arnold, and Inge Morath, at the time a beginner. Marilyn Monroe had the final word on any pictures, and in order to make sure her choices were respected, she stamped the contacts and the negatives of all the photographers present at the filming. Luckily, all those which received simply a big red "R", for refused, were

saved. In this film, the actress's work approached perfection; a veritable fusion took place between the star and the camera lens. A woman was heard exclaiming: "My god! She's making love with the camera!" An electrician was heard to answer: "No, ma'am, she's screwing the camera!"

In 1961, Marilyn posed for Douglas Kirkland. "Before I had even got my camera ready, she was already protesting: 'I can't work with this fabric. If it were silk, I could feel something.' So I led her to the bed, which had silk sheets. She slid in, got rid of her clothes that she gave to the stylist. Then she asked everyone to leave, saying she'd feel more at ease in front of the camera if we were alone. My assistant put the film in the camera, took pictures of me working with her, then left. About two thirds of the way through, Marilyn said, 'I want you . . . I want you . . .' I think any normal American would have given in instantly. But, because of my loyalty to the camera (and my fear too, probably), I didn't move and continued to take pictures. Was she sincere or was she playing a role? Leaning against the bed, taking pictures of her, I showed her what affect her words had on me . . ."

The good photography fairies were still there, but those of life became more corrosive, gnawing at Marilyn. The offhand partners to Hollywood's apocalypse, barbiturates, alcohol, abortion and solitude, were taking their toll. Her marriages to Joe DiMaggio and Arthur Miller were both short-lived, her attempts at motherhood a failure, and her affairs (notably with the Kennedys) ended in sadness and resentment. Insurance companies complained, studios dismissed her and lovers fled. So once again, she turned

to photographers to rediscover the magic. For four months, from May to August 1962, she posed in the nude for Larry Schiller, William Woodfield and James Mitchell while filming *Something's Got to Give*, which was left unfinished.

S ix weeks before her death, she agreed to a shoot with Bert Stern. "I was a photographer for *Vogue*. I had a few pages in the magazine and I wanted to print a delicious image that would be one to remember, a woman: Marilyn Monroe accepted. It would be a classical portrait, in black and white. A timeless portrait. But to be perfectly honest, what did I really want? I wanted to have Marilyn Monroe, alone in a room, in the simplest of clothing. A hotel room . . . I had found it, the Hotel Bel-Air, hidden away in the hills; the most sumptuous and discreet hotel in Los Angeles. Each room is designed to create perfect intimacy. But there was no way I could just come out and say to Marilyn Monroe: 'Hi, I'm Bert Stern. Get undressed.' Perhaps I could get what I wanted through the cunning of veils and screens . . . So I asked *Vogue* to provide me with transparent scarves with geometric forms, and jewelry. At the Hotel Bel-Air, we were given an upstairs suite, Number 261. I turned it into a studio. Other than the lighted space, I had to create a soundstage, so I brought my stereo. The telephone rang, it was Pat Newcomb, Marilyn's press attaché: 'Hello, Bert, everything okay?. . . Could you order three bottles of Dom Pérignon 1953 for Marilyn tomorrow?' She was supposed to arrive at about two in the afternoon. George Masters, the hairstylist she had chosen, arrived early. Two o'clock . . . three o'clock . . . four o'clock... finally the phone rang: 'Miss Monroe is here,' a voice told me. She had lost a lot of weight and she looked transformed. She had

become more seductive than the woman with generous curves that I was used to seeing in her films. Wearing pants and a light green cashmere sweater, she was thin and elegant. No makeup. She was sensational. I was in love. I said to her: 'You are beautiful.' I showed her the room, and she sat with her hairstylist. I opened a bottle of Dom Pérignon and filled two glasses, which we emptied. As she leaned toward the mirror to put on her lipstick, her gaze fell upon the multicolored scarves thrown on the bed behind her. She went to the bed and felt them, intrigued. 'What are these?' she asked me. 'I brought them so you could play with them, if you like them.' She took them, examined them, looked at one under the light. 'Would you like to do some nudes?' she asked me. She'd discovered my secret. When Marilyn got onto the set, she was barefoot, a glass of champagne in one hand and an orange-striped scarf around her bust. 'I won't take my pants off,' she said. 'So, slide them down your hips just a little. Like that. Marvelous! That's wonderful.' I started shooting. I wanted a very clear Marilyn, in a flood of light. Finally, all that remained were two muslin roses. I held them out to her. There was only one thing she could do with them: hold them at the tips of her breasts. She started to like it, I could see it, feel it. But if I didn't shoot when she wanted to, she started to laugh. It was late at night, near dawn, when I finally got her to remove her clothes. I held out a scarf with black and white stripes. 'You know, for this one, you should take off your pants,' I said. 'Okay,' came her simple reply. And, holding the scarf in front of her, Marilyn let her pants fall. And I started taking pictures. You could imagine her magnificent body behind the black and white scarf . . . Until she finally let that fall away too, and I pressed on the button, for no one else but me . . .

"As soon as I got back to New York, I sent the color photos to the lab. I developed the black and whites myself. Five days later I got

the colors back. I put them all in a large envelope and went to see Alex Liberman at *Vogue*. He went to the brightly lit table, took his magnifying glass and looked over the pictures. I could see that he was looking at them very closely, passionately. 'Beautiful, Bert,' he said to me, 'just beautiful.' So I was very happy when I got back to my studio on East 93rd Street. I could just see a two-page full color nude of Marilyn in *Vogue*. When I got home, there was already a message asking me to call back *Vogue*. I got Alex immediately: 'Bert, we love the photos,' he said, 'but,' here we go, I thought to myself, 'they're so wonderful we'd like to do ten pages. We'll have to do others in black and white.' 'Okay,' I said, 'if Marilyn accepts, I'll do more.' The next day, *Vogue* called me back, saying that Marilyn was delighted with the idea. Alex informed me that *Vogue* would send Kenneth for the shooting and dispatch Babs Simpson, their best staff writer. I took the plane for California with my assistant, Peter Deal. Once we were there, we were able to get the biggest suite at the Bel-Air, Bungalow 96. I decided to take the photos in the bedroom and got rid of all the furniture except for one divan. Babs arrived from the airport in a limousine. When I saw the number of clothes and furs, I had to laugh. It seemed that *Vogue* was doing exactly the opposite of my original intentions. At least we weren't going to run out of Dom Pérignon. We were even brought a case of Château Lafite: only the best for the most beautiful girl in the world. Marilyn made her entry at five o'clock. *Vogue* wanted Marilyn dressed in all her finery. As for me, I only wanted to see her in the nude. The more Babs added to the refined style, the harder I worked to reveal her charms. Marilyn started getting impatient, it was after midnight and there were still several models which needed to be seen. She was no longer letting herself go, I could feel her slipping away. 'I've had enough of all these dresses,' said Marilyn. 'Isn't there anything else? What's this?!' she

demanded, holding up luxurious muslin lingerie trimmed with two frills, 'you call this fashion?' She changed in the bathroom and came back out in the strange garment. Two layers of black muslin, I could see . . . her magnificent breasts. 'Not bad, for thirty-six years old?' 'You're scaring me, Marilyn,' I told her, looking her straight in the eye. I turned to Babs. 'Could you leave us alone for these pictures?' She left the room, we were alone. Our time had finally come . . . 'What do you want to do?' she asked me. 'Well,' I said, 'why not get into bed?' Marilyn slid in between the sheets. 'And maybe get rid of the towel,' I suggested. 'It's making bumps.' 'You know,' I told her, 'you are splendid. But that bed jacket is no good.' So she took off the bed jacket under the sheets, while I took photos. She started to let the sheet slide. 'Why not lie back without showing anything?' I suggested. 'How?' 'Well! If you put one foot on the ground, all we'll see is your lower back.'

I wanted a perfectly pure nude, without any clothes, nothing but air between her and me. We were getting there, little by little. I was right above her. I no longer knew if I wanted to photograph her or take her in my arms. She was vulnerable, drunk and tender, attractive and exciting. Marilyn's gaze was more intimate, sleepy. I leaned over her. When my lips brushed up against hers, she turned slightly away. 'No,' she said. I slid my hand under the sheet and touched her skin. Everything fell still around me. She came closer. I was touching her . . . We weren't far from pure erotic pleasure. Then she wanted to make love. She was enthralling. I was the one who stepped back. Slowly, I took my hand away. She opened her eyes a little, stretched and said to me:

17

'Where were you this whole time?' Those were her last words that night. She fell asleep . . . I showed the proofs to Alex Liberman and asked him to give me a few of the color nudes that I wanted to send to Marilyn, and I waited. I finally received a fat envelope. There were X's on half the pile! When she left her mark on those pictures, she only had two weeks left to live."

from June 1st to July 18th, 1962, George Barris photographed Marilyn and recorded her about ten times for a biography that was published twenty-five years later. In it, we find out about the surprising relationship that Marilyn had with nudity, eroticism and sexuality. The images of a nude Marilyn Monroe reading, relaxing or simply walking in her own home are often described as narcissistic. In fact, Marilyn found a strange comfort and an impression that she was at one with herself in this childish attitude which had provided for her the rare sensations to live, and rediscover the real Norma Jean. Nonetheless, her nudity in public or in the presence of men, other than her husbands or lovers, was much more premeditated, conscious. Before being an adolescent, she was already seeking out this new interest that her growing body provided her with, even if she hadn't yet understood or shared in its sexual goal. "I used to lay in bed at night, wondering what boys wanted from me," remembered Marilyn. "I didn't want them like that. I wanted to play games in the street, not in my room. From time to time, I would let one kiss me to see what it was about, this ritual. It didn't interest me. I finally told myself that boys were interested in me because I was an orphan and had no parents to protect me or scare them. This attitude calmed me a lot . . ."

As a young actress and model, this protective disposition steered her away from posing nude or acting in pornographic movies like so many other starlets in need of money. But throughout her whole life, her dilemma—like her art—was to reveal herself enough to draw the attention she needed so badly, all the while making sure she didn't show too much, so she wouldn't be ridiculed, victimized. It is another dilemma of this culture for a woman whose beauty was her only power.

When intimate, Marilyn used her body like a gift, and what she received in return was love and comfort. In *After the Fall*, the 1964 autobiographical play by Arthur Miller which tells of their marriage, Maggie gets undressed in front of her new lover, like a child giving a gift. According to what Marilyn confided to her friends, her body was not a source of sexual pleasure. Her lovers have often said that she was generous, loving, and looked more to please the other than herself. Marilyn had an intense love of "giving her body" to her lovers or her photographers, a way by which she could garner the total interest she needed to feel unique, valued and trusted. Photography took from her all that generously offered beauty, and in return, she received a few moments of acknowledgment and love. And we can still feel it forty years after she left us.

Her last photo session was with Allan Grant, photographing her for *Life*. On August 4th, Larry Schiller dropped off the nudes at Marilyn's home. She sent back her choices the same day. True to herself, she meticulously crossed off about half the images. She died a little before midnight on the same day. It's been said she wrote her own epitaph: "37-22-35 RIP" . . . her measurements.

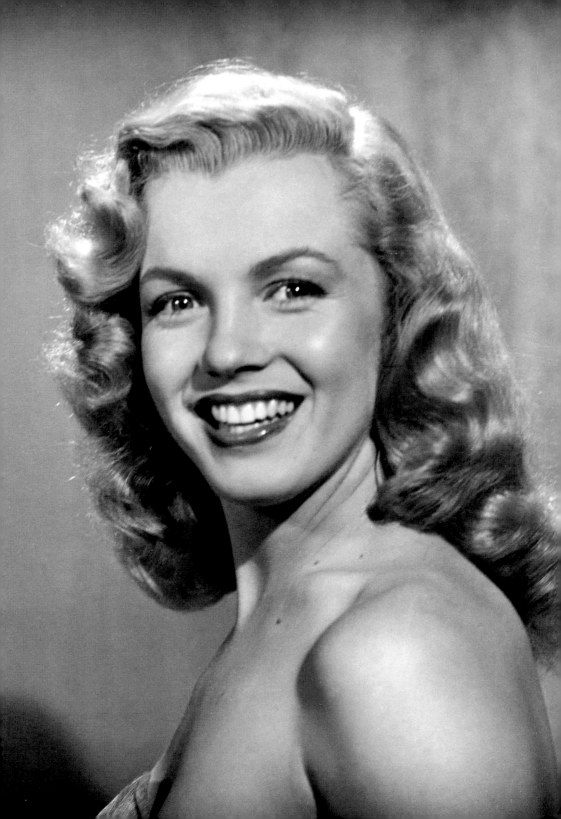

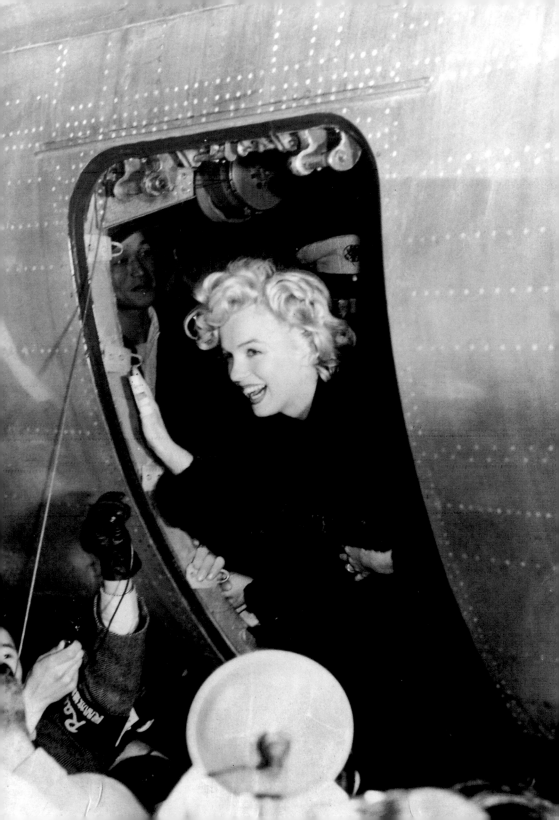

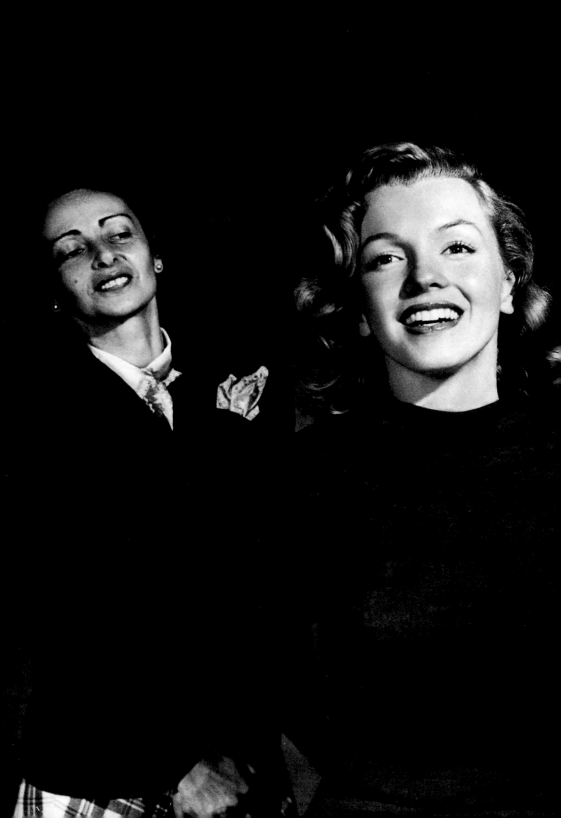

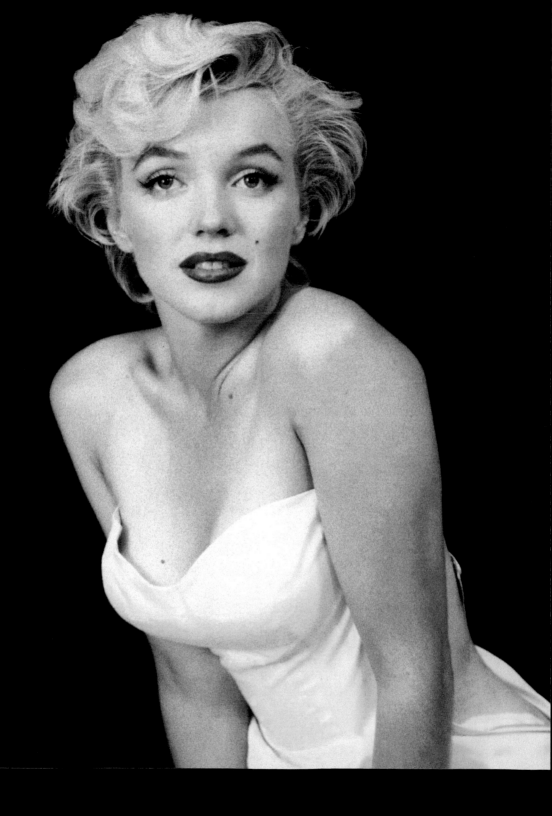

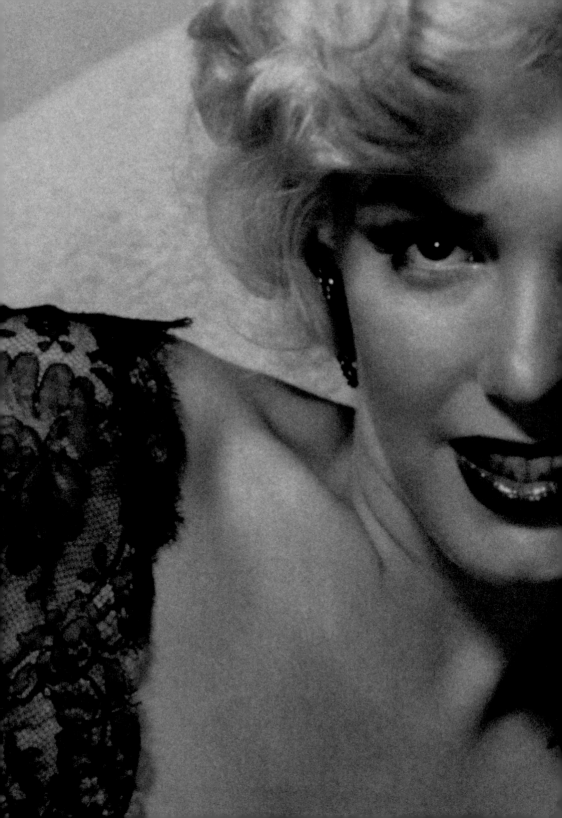

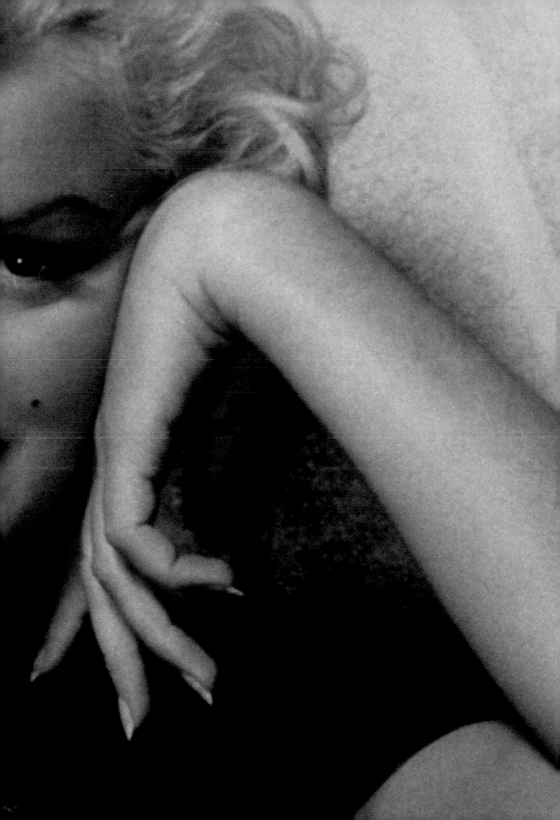

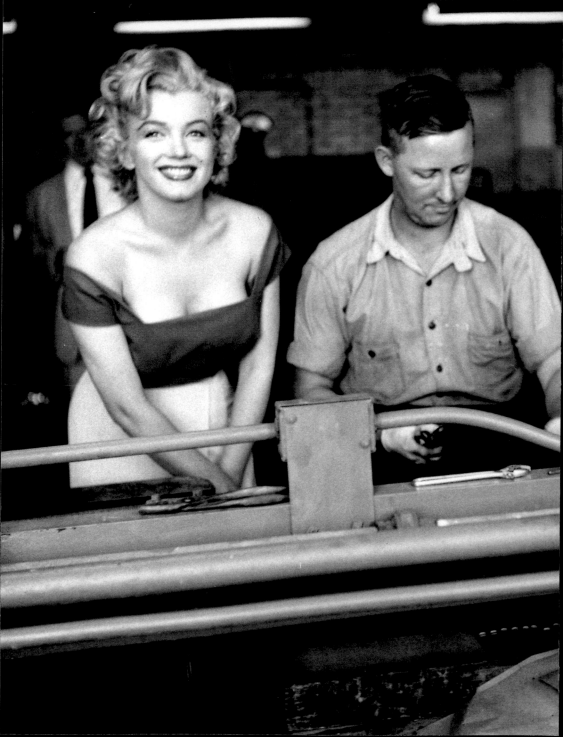

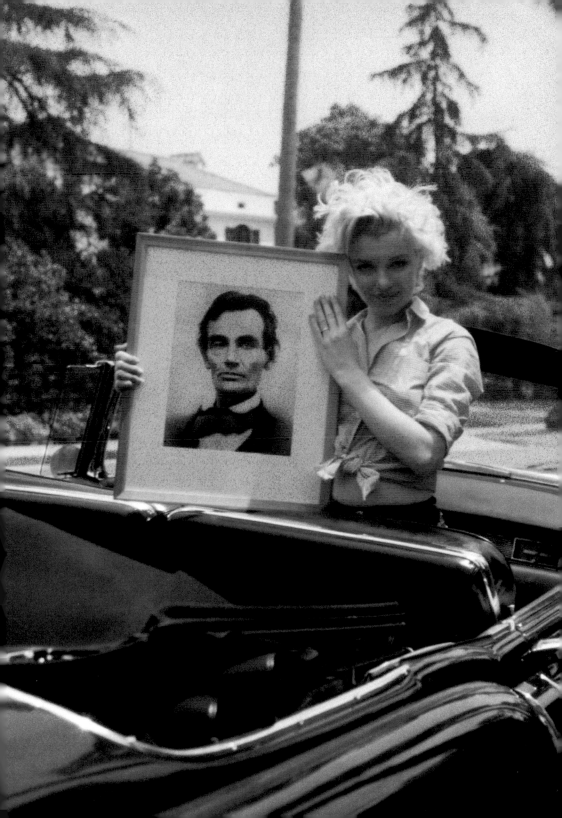

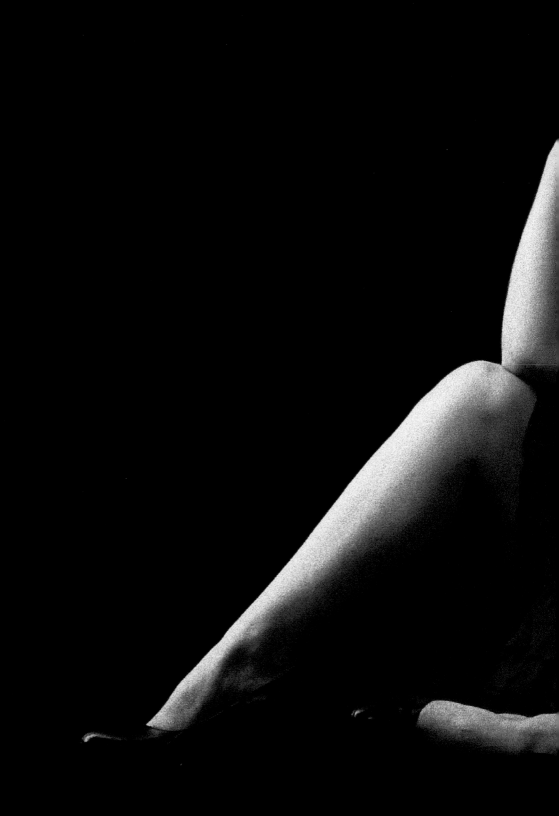

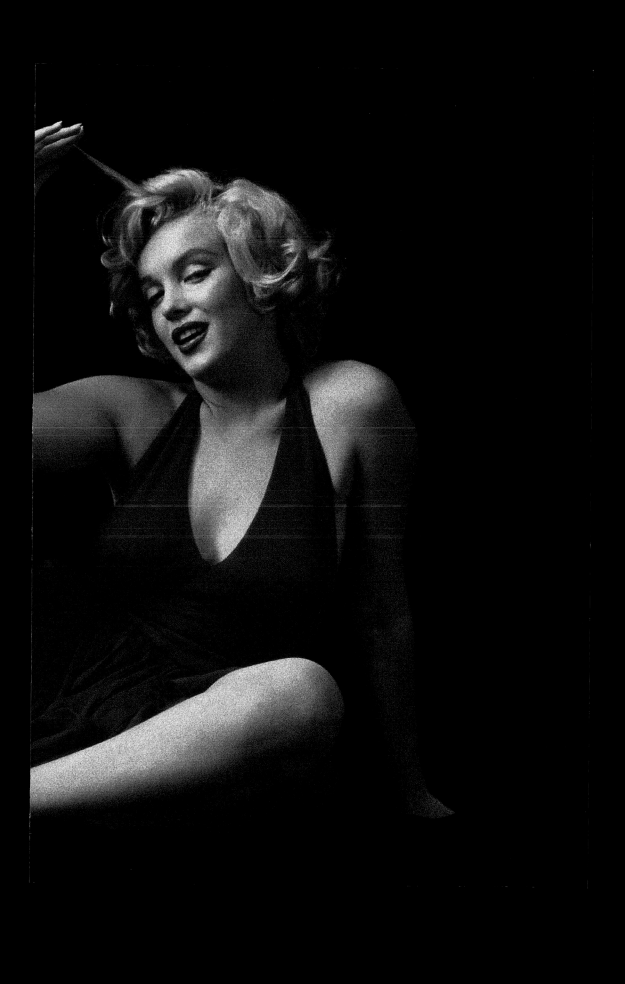

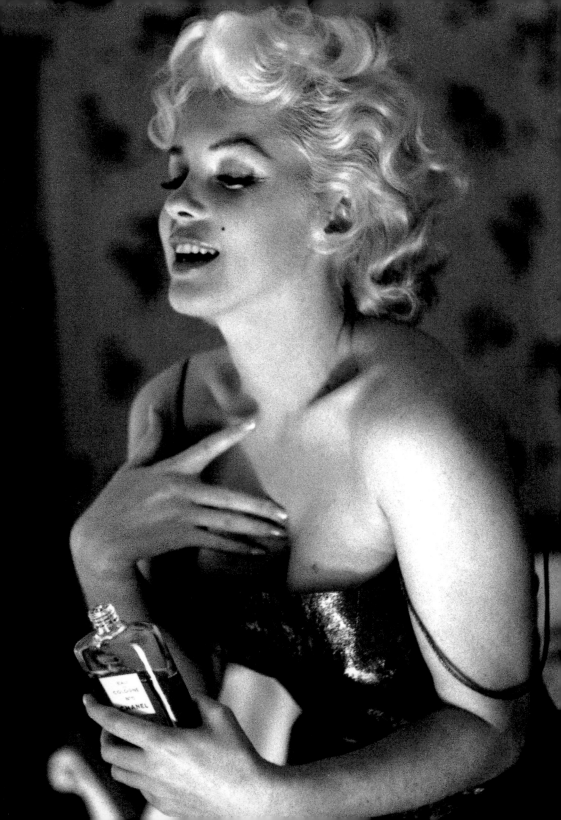

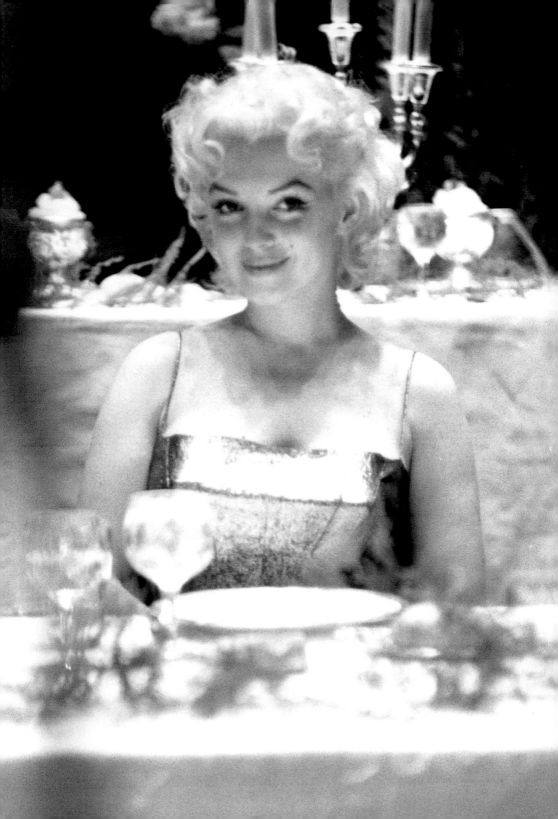

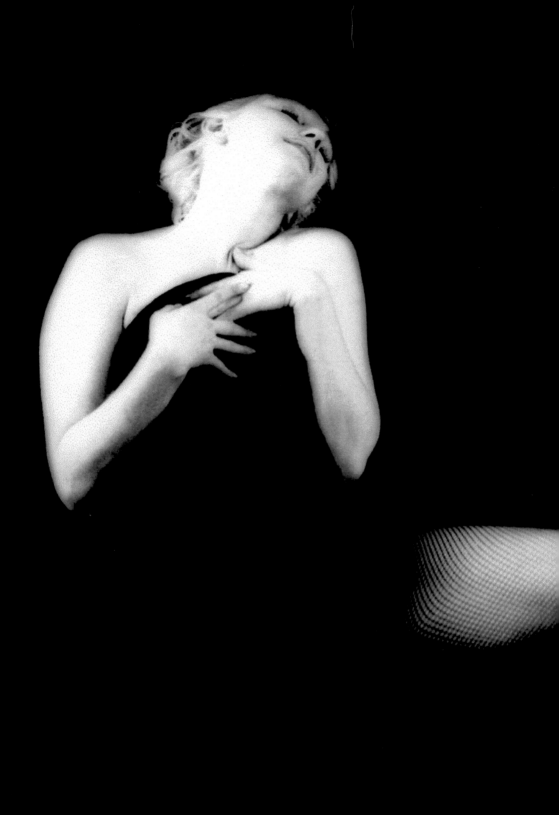

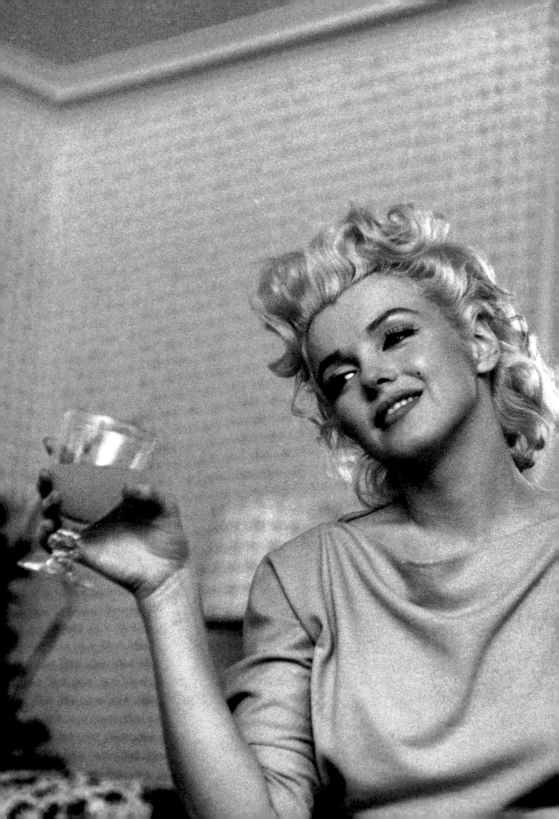

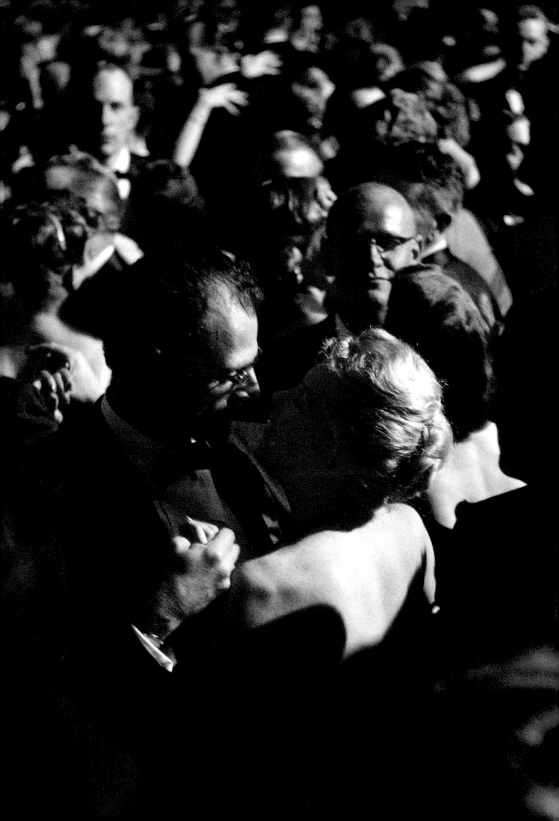

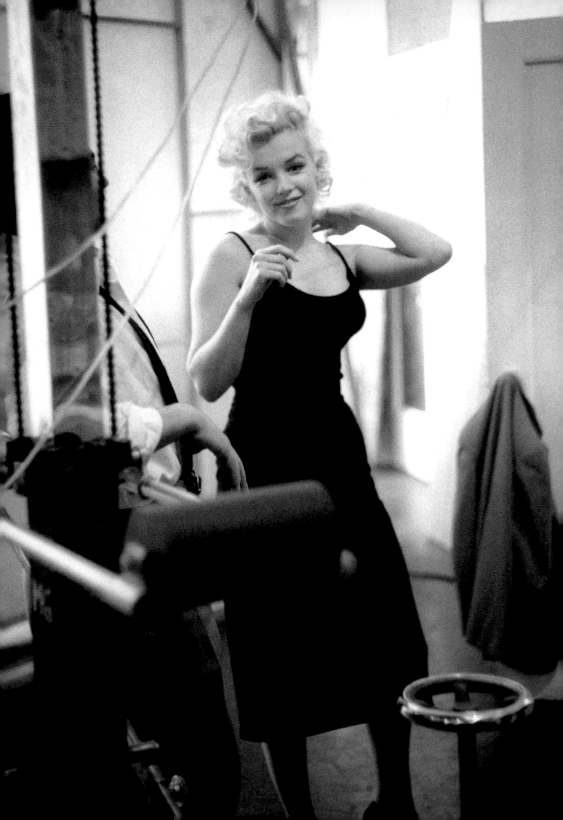

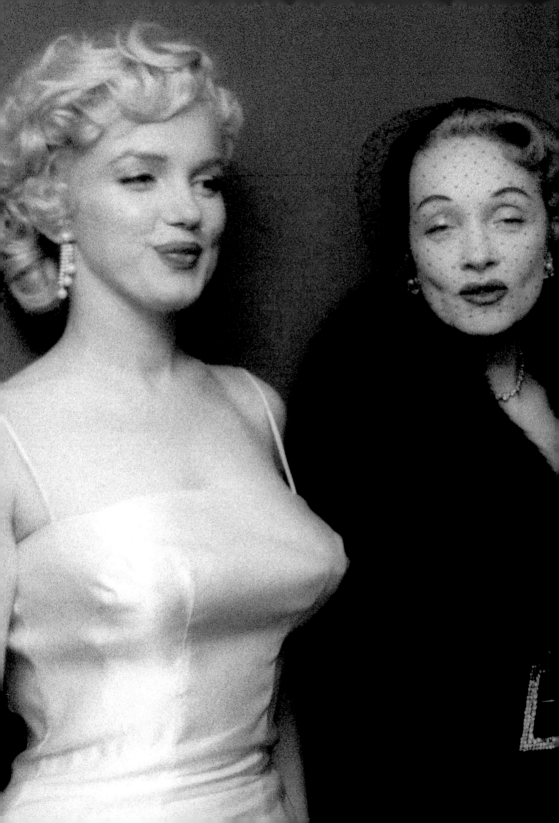

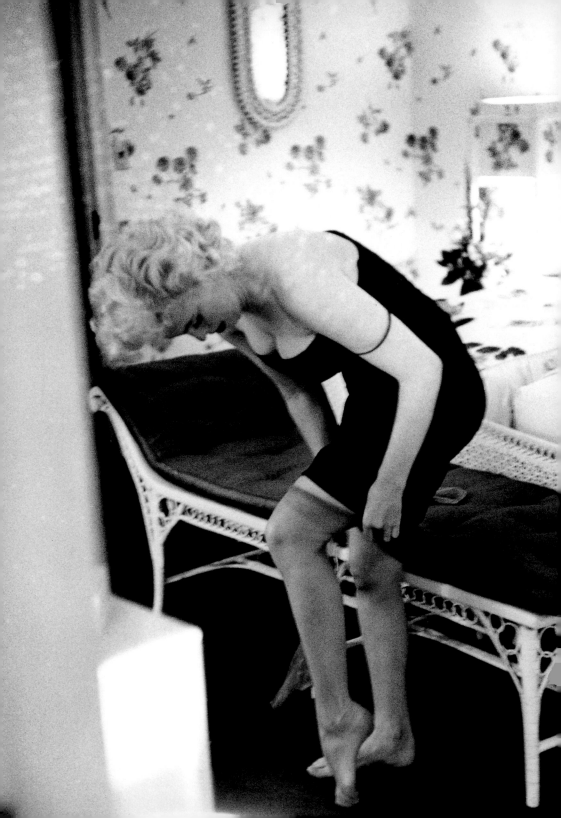

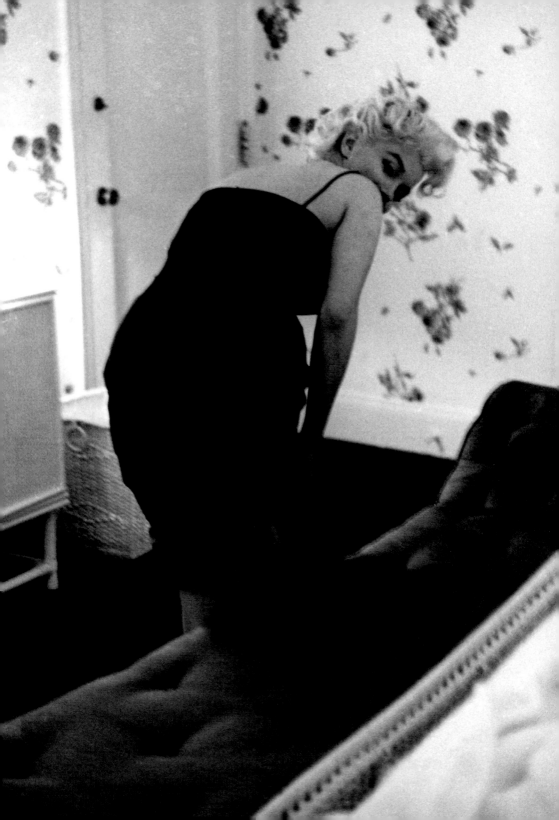

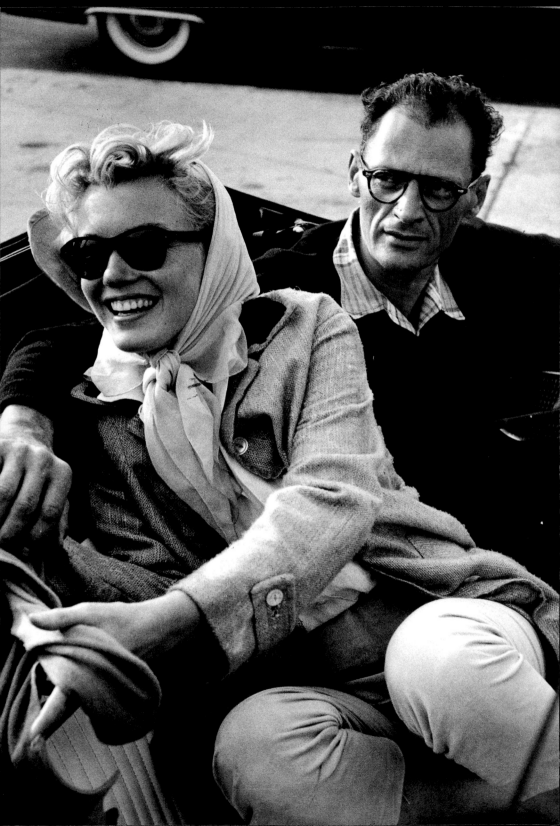

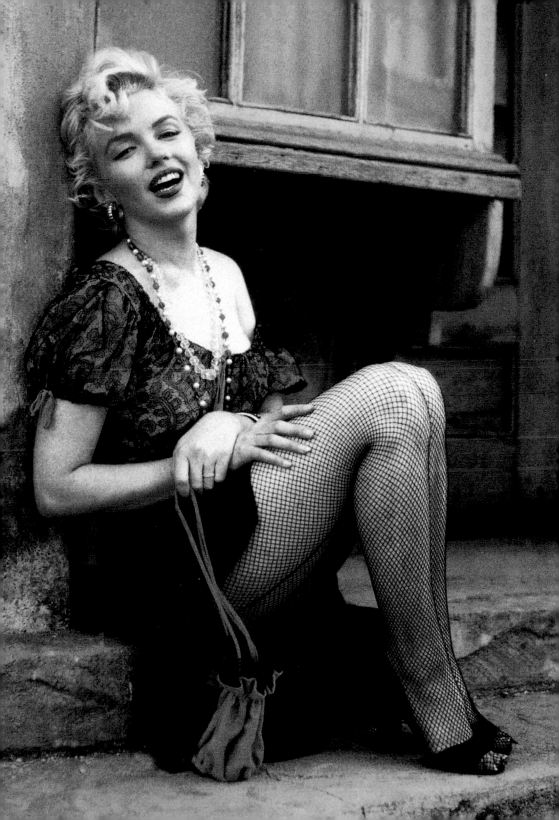

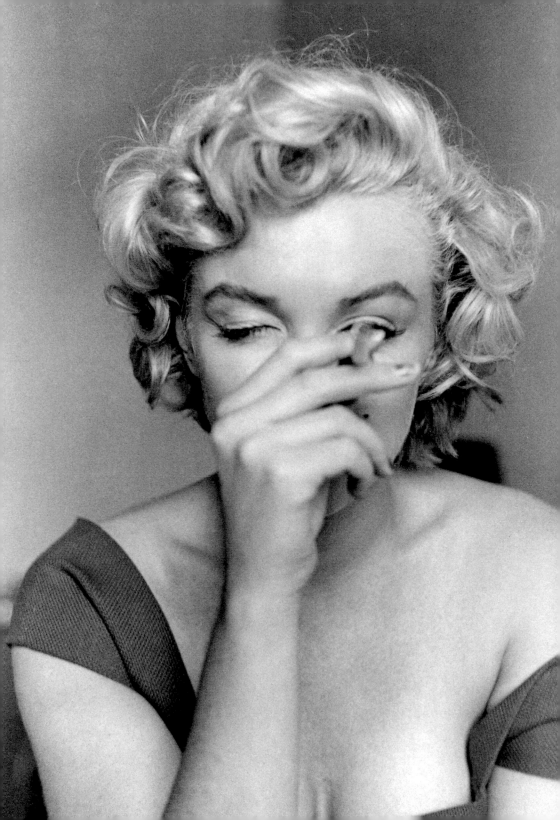

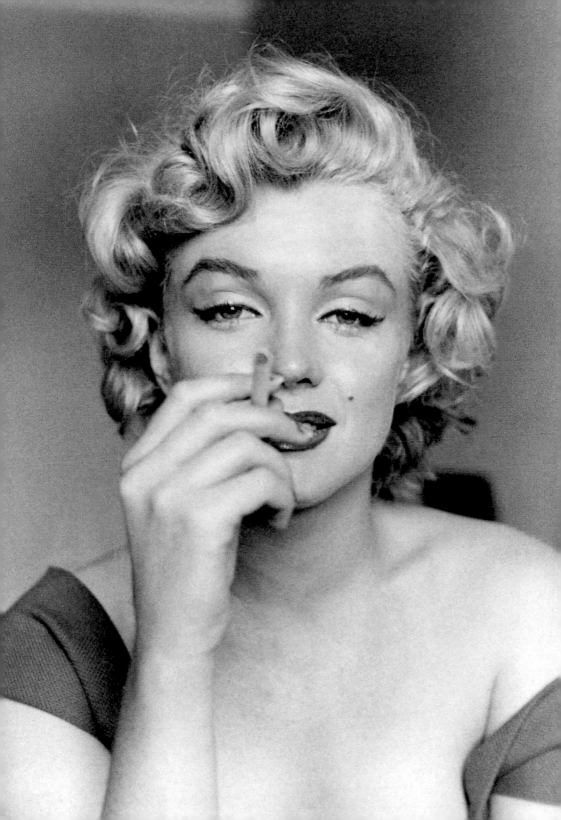

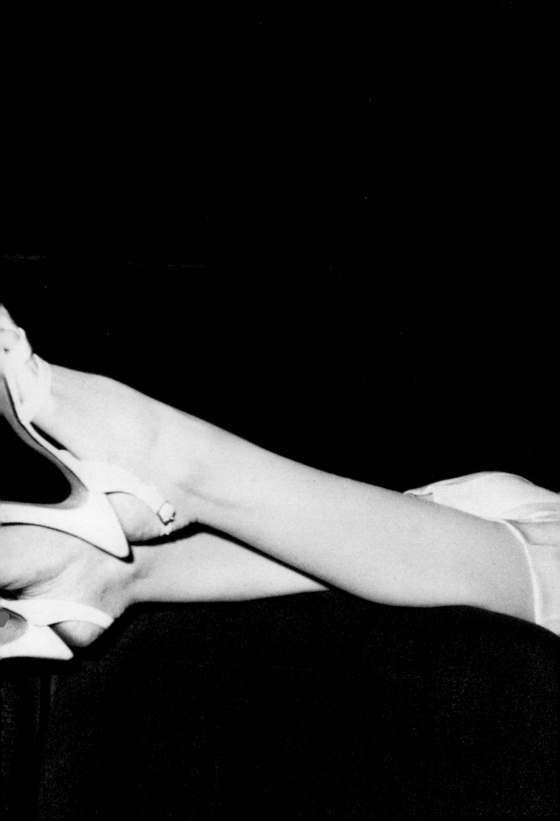

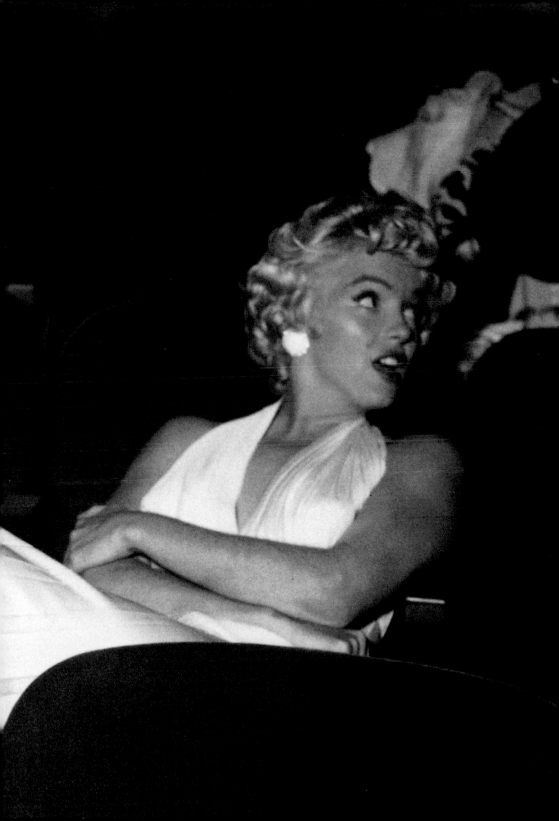

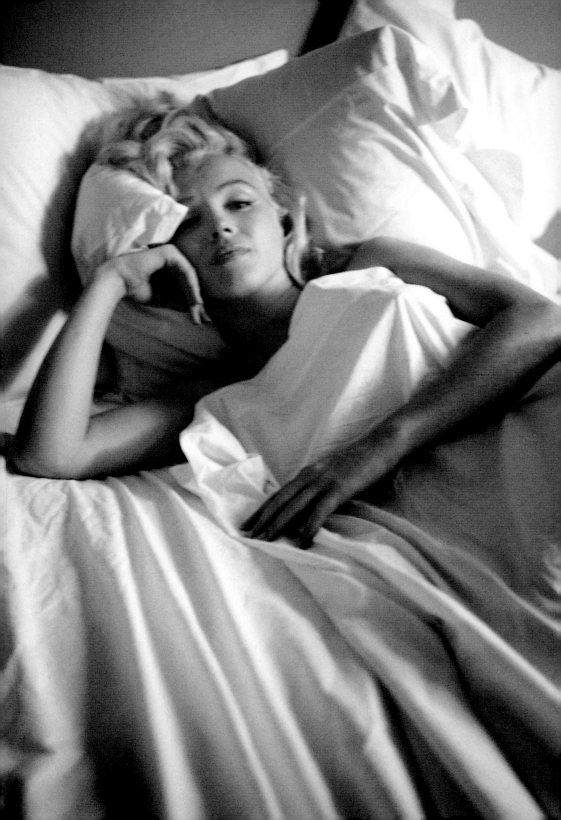

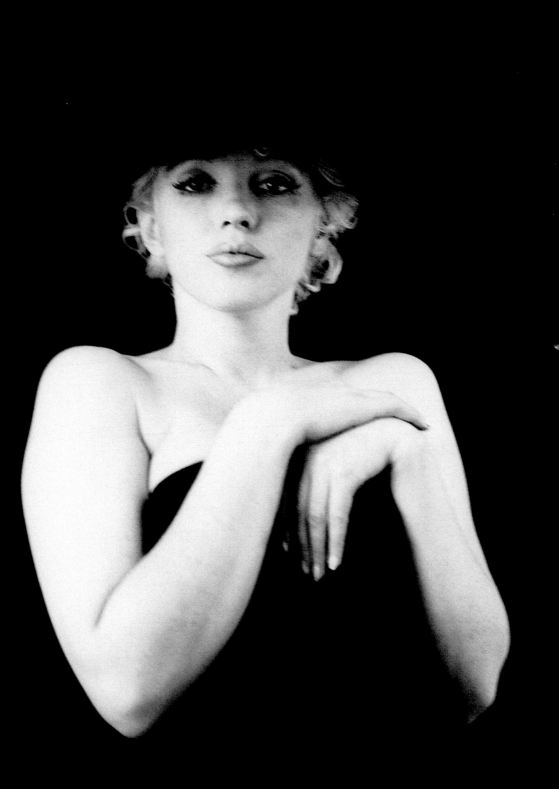

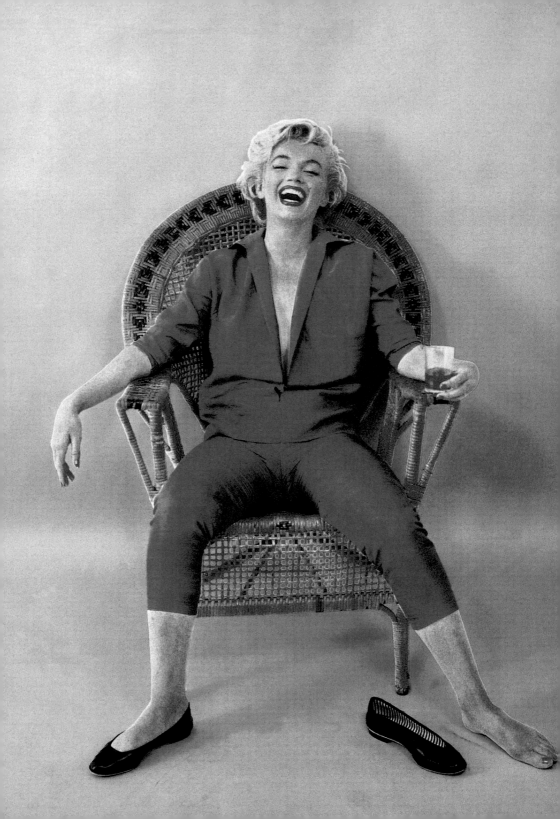

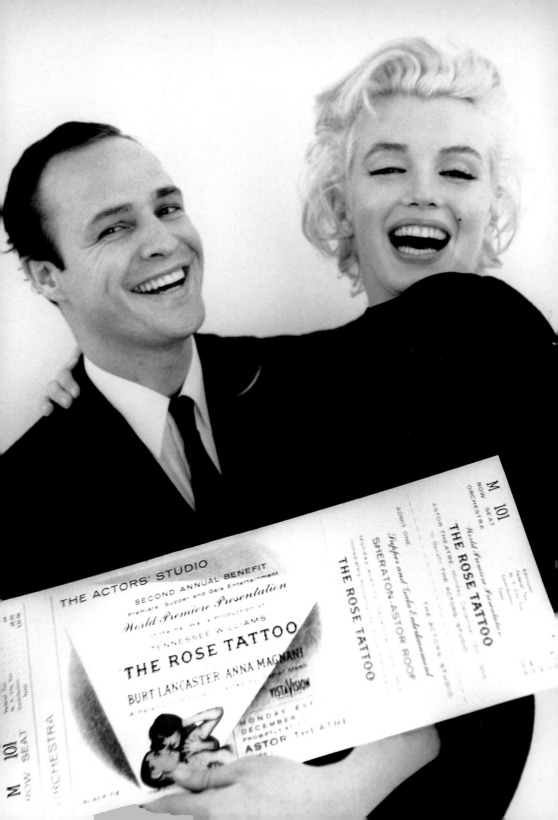

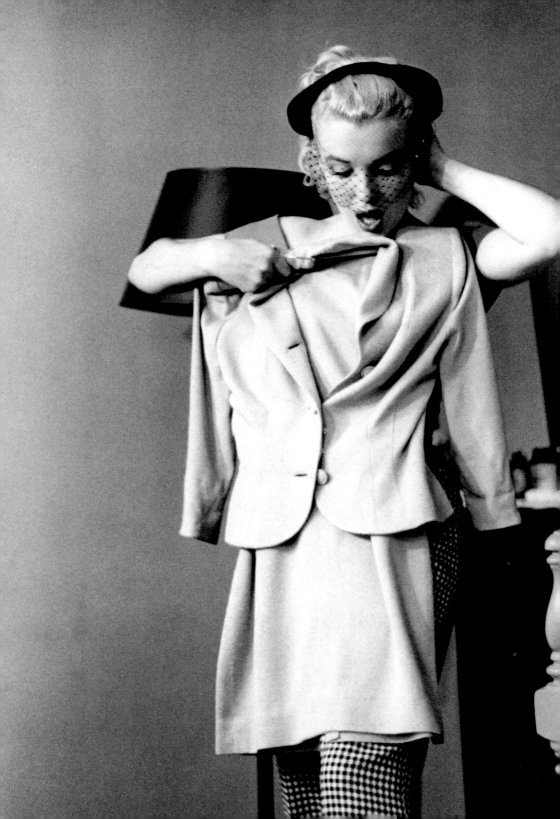

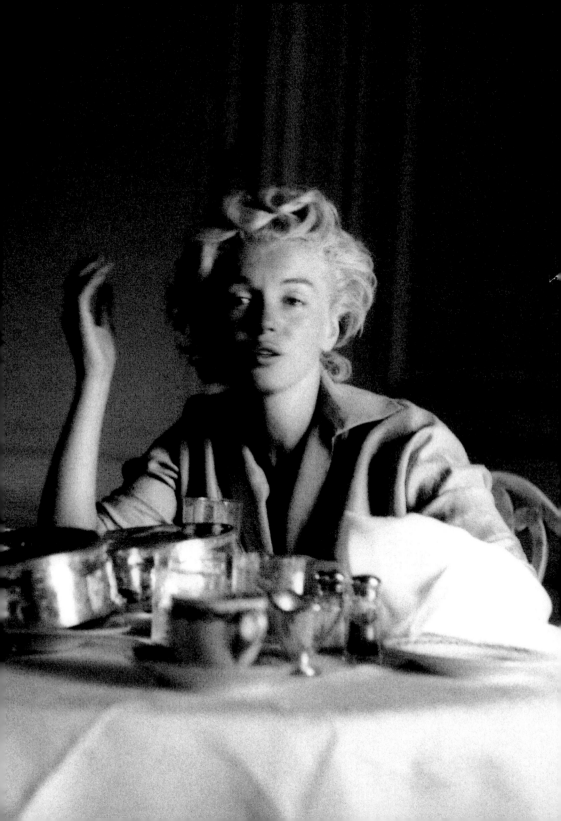

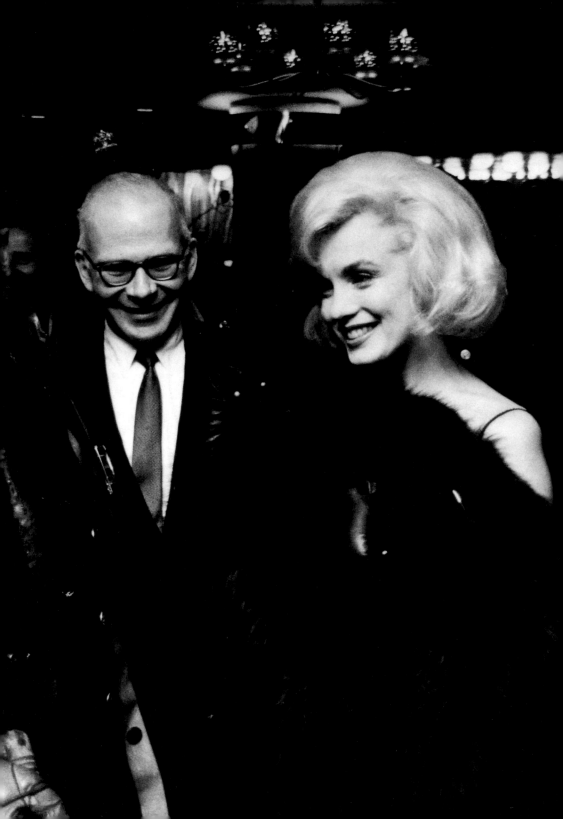

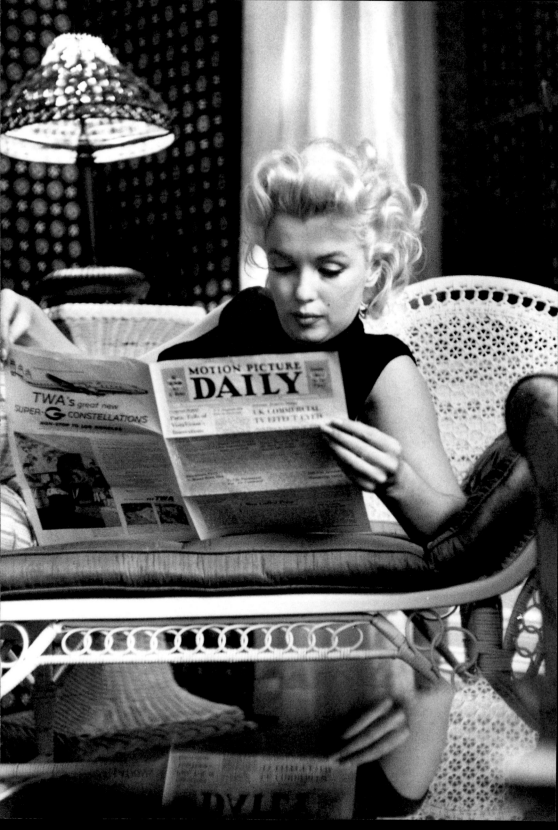

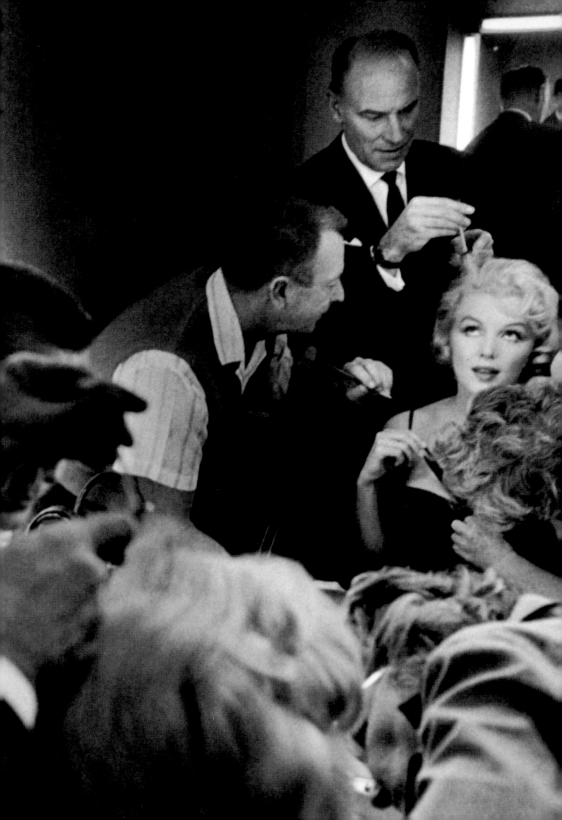

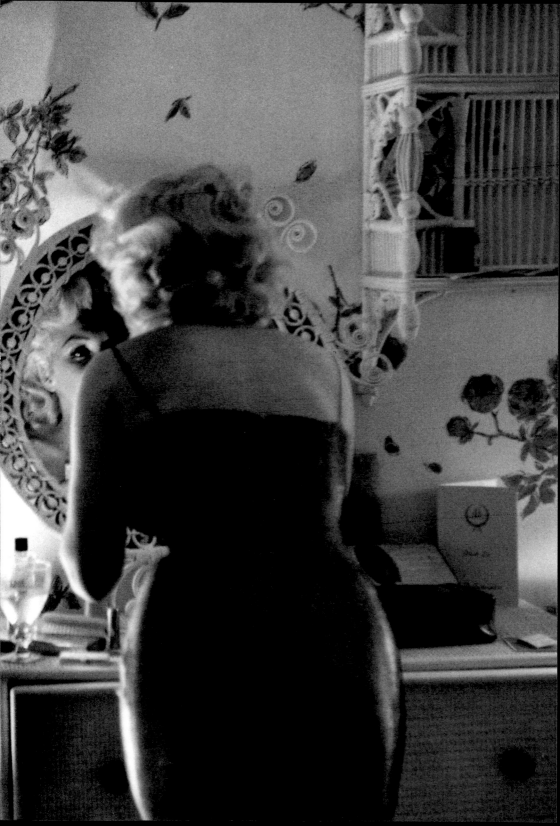

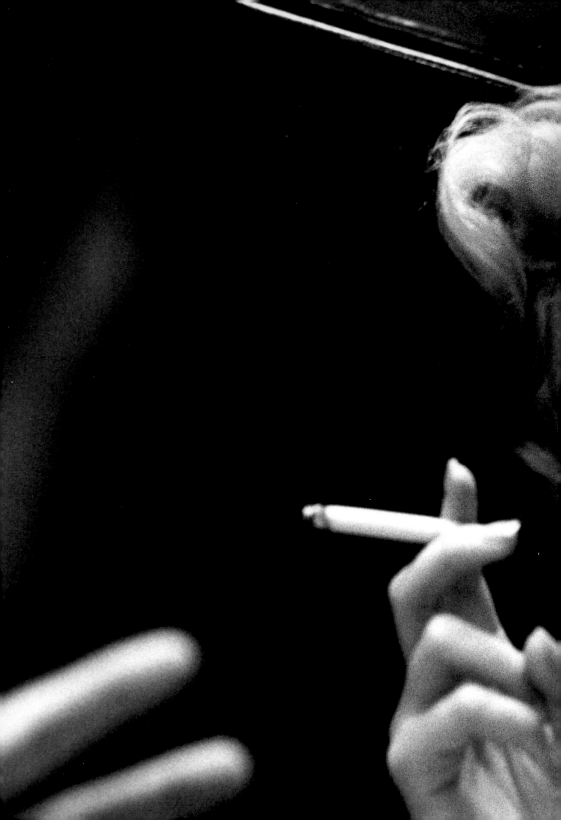

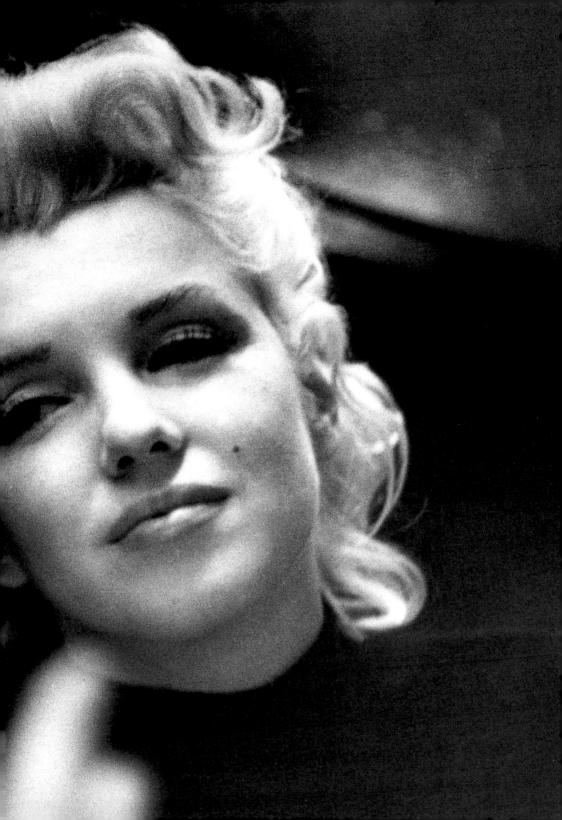

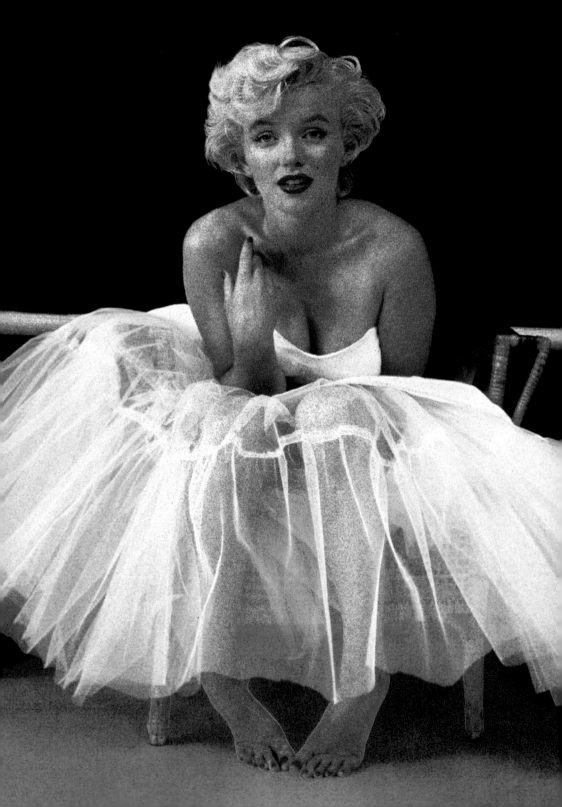

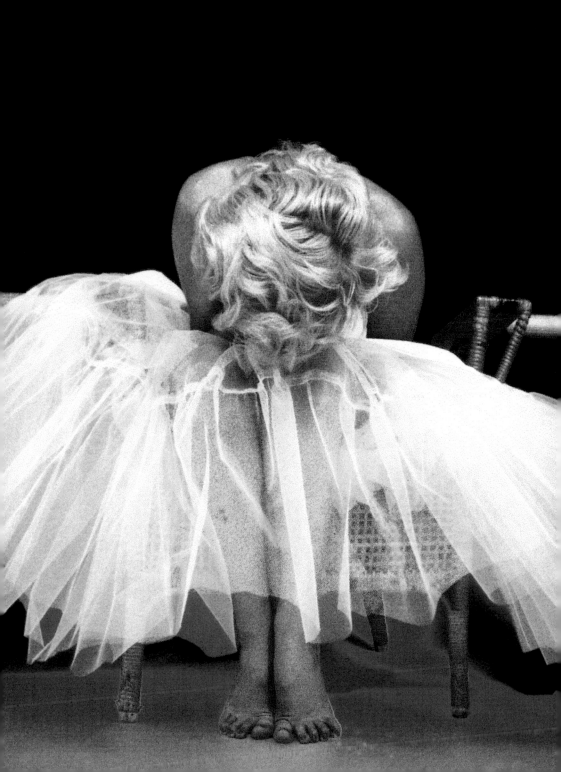

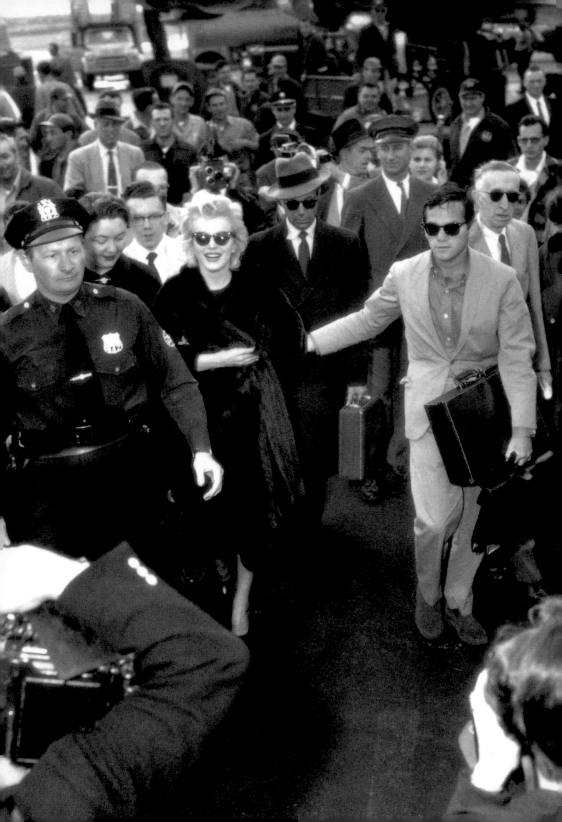

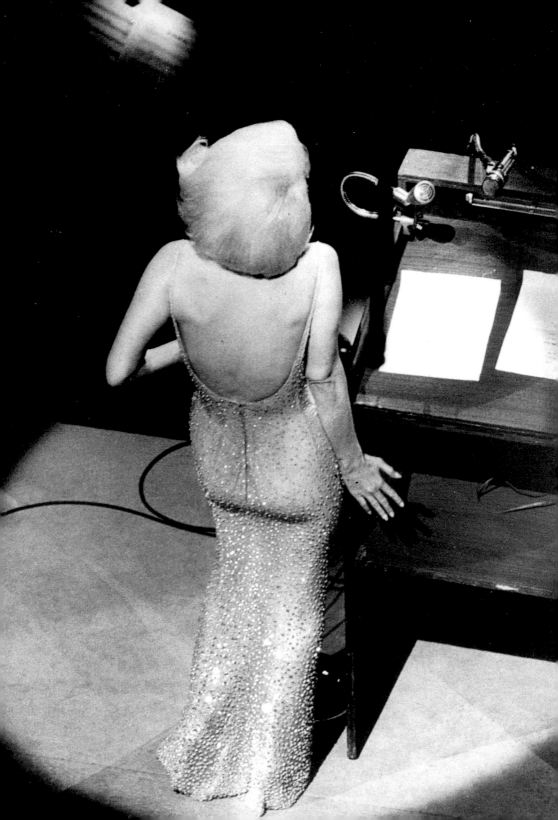

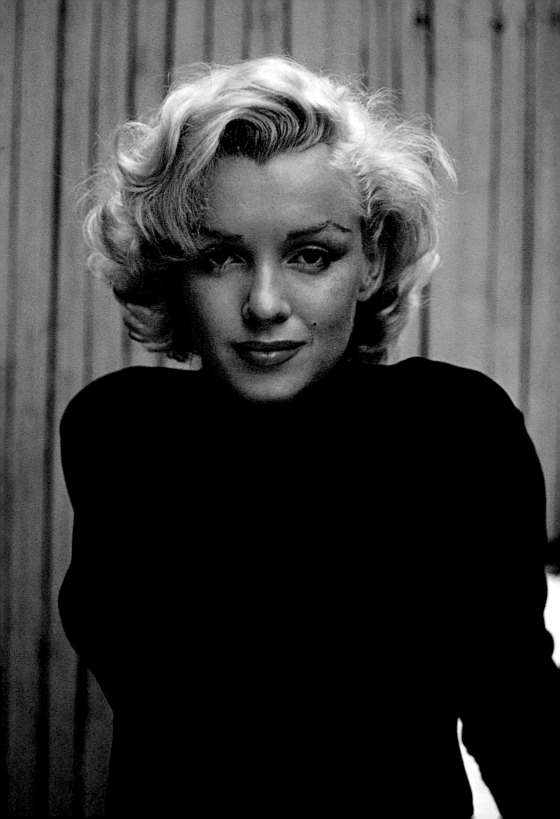

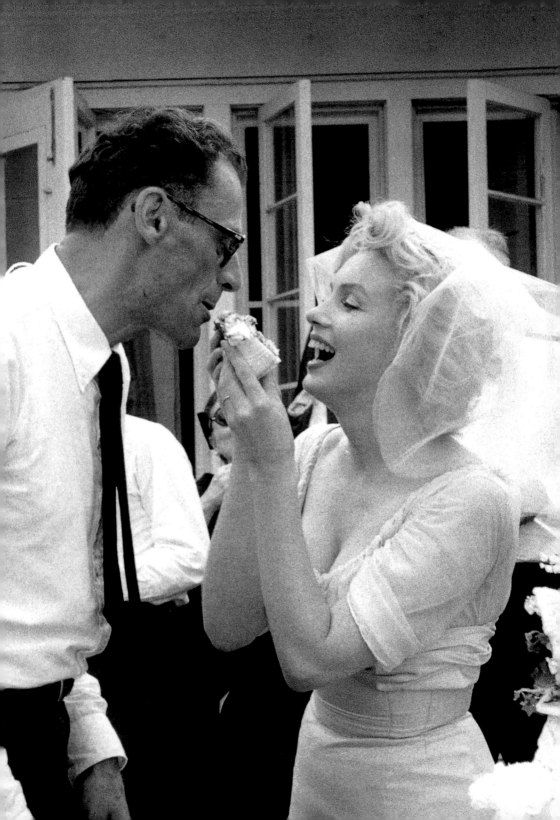

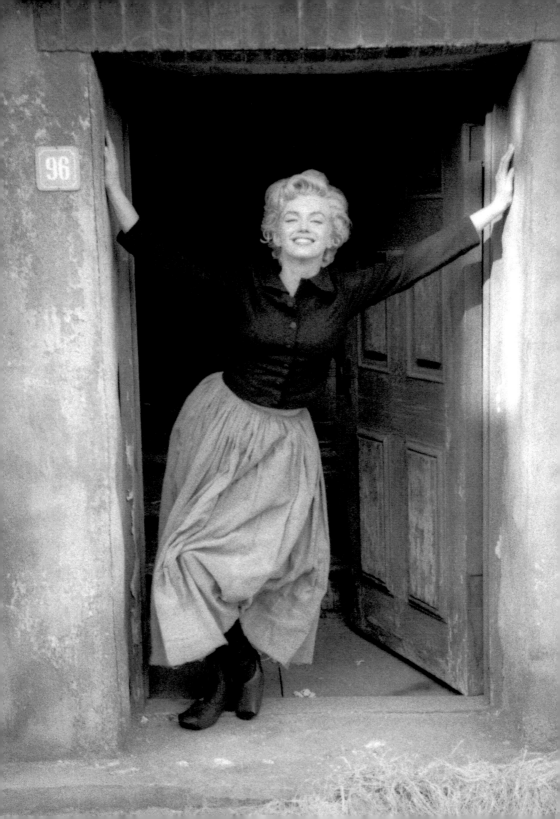

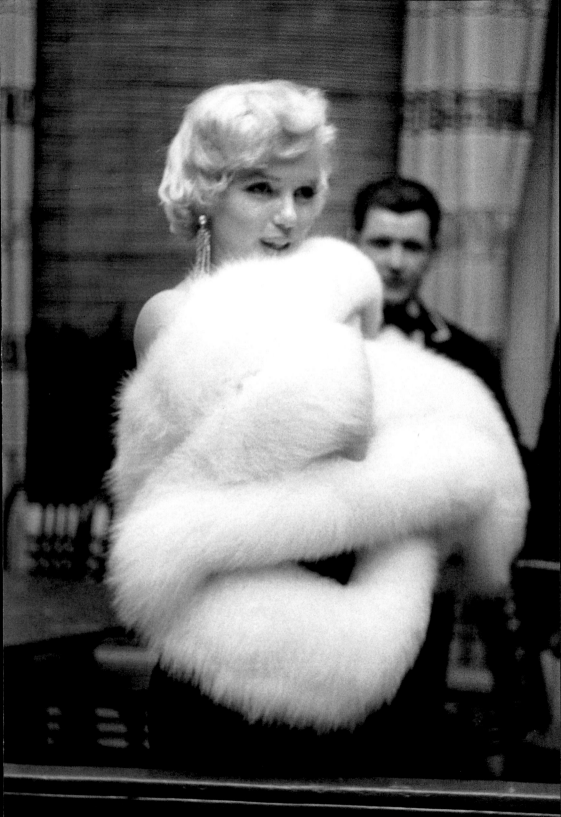

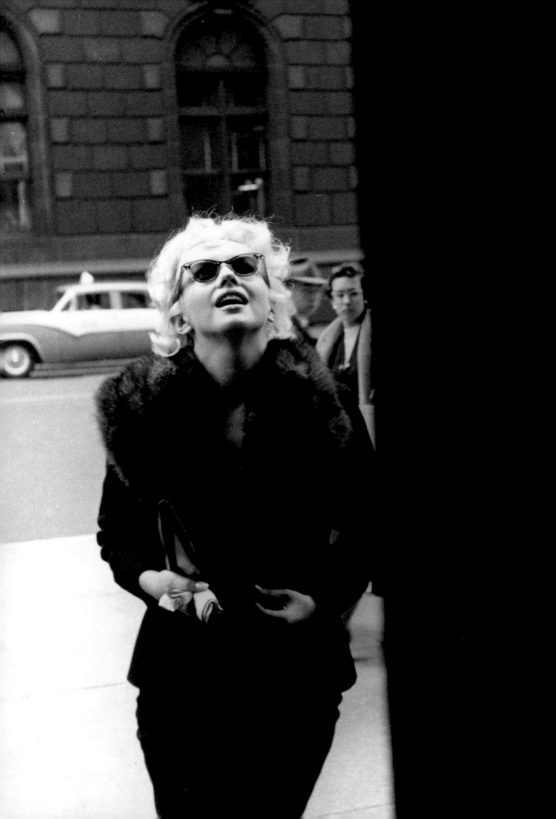

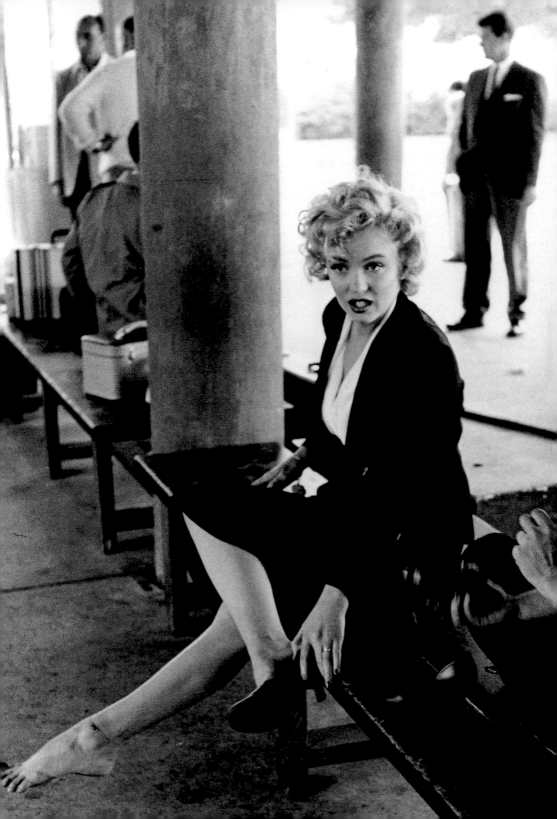

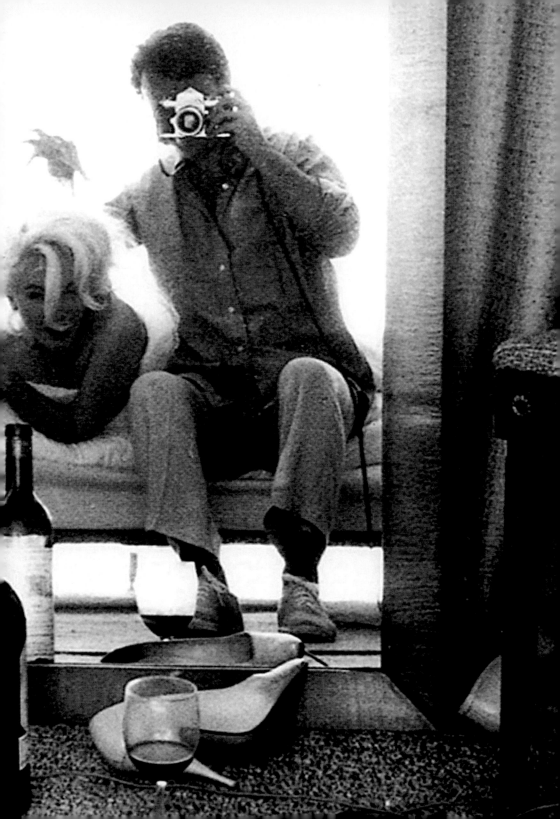

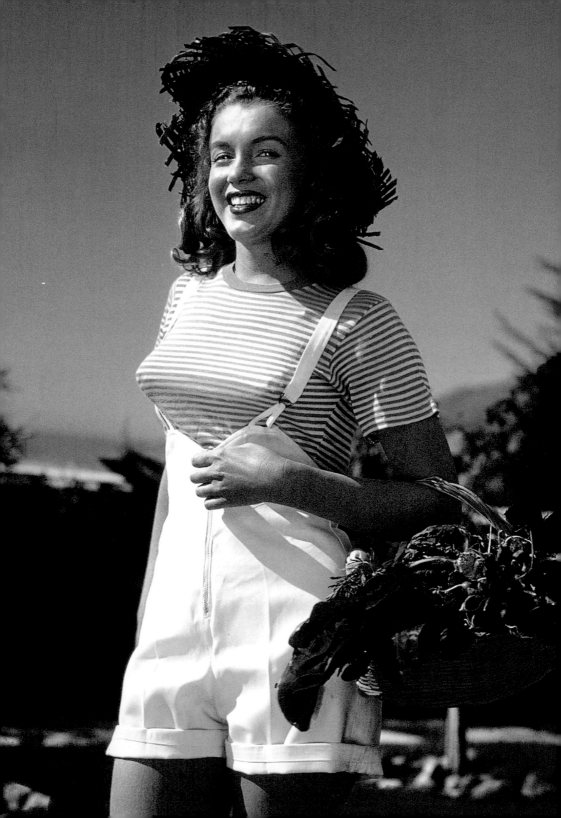

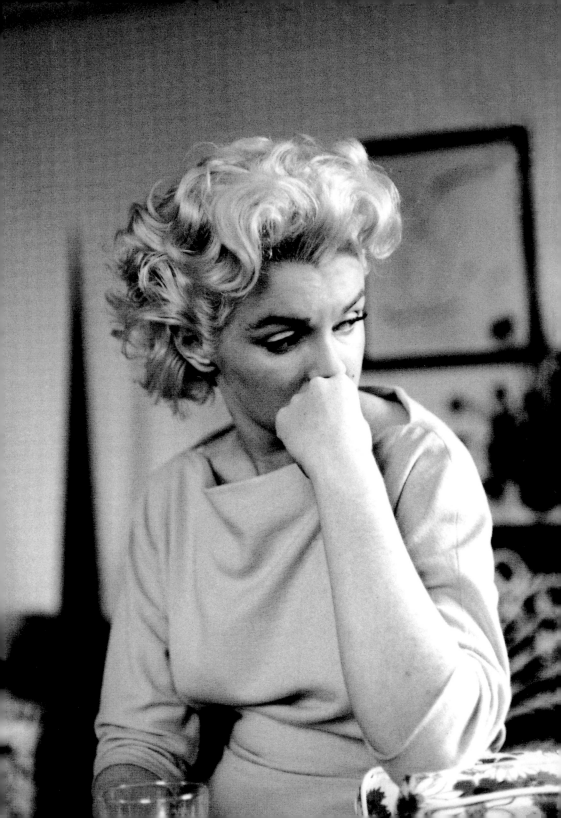

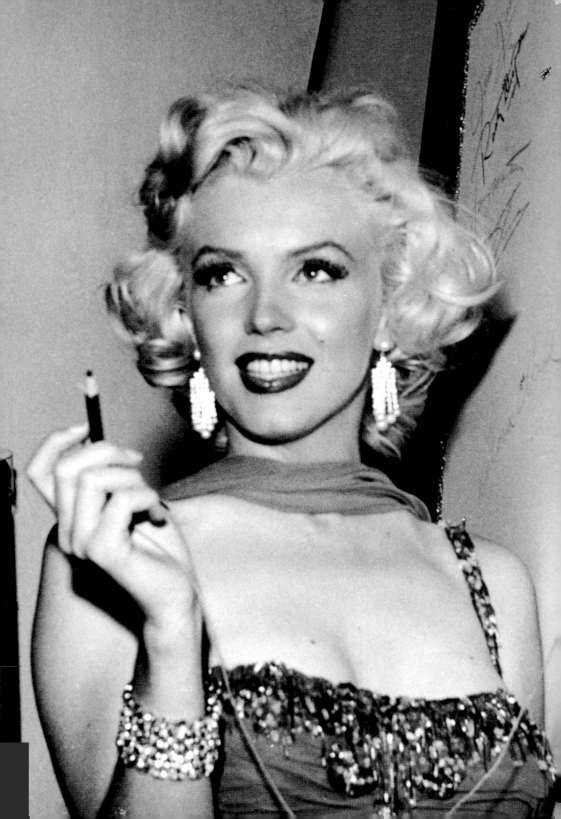

Chronology

1926: June 1st, Norma Jean Baker was born at the Los Angeles main hospital. She was the daughter of Gladys Monroe Baker and was acknowledged by Edward Mortenson. Later, her mother revealed the identity of her real father, C. Stanley Gifford, who worked with her at Consolidated Film Laboratories.

1934: In December, her mother had a breakdown and was institutionalized. Grace McKee, a close friend of her mother's, became Norma Jean's guardian.

1935: Grace McKee could no longer take care of the child, who was put in an orphanage on September 13, before being placed in nine successive foster families.

1942: Norma Jean had just turned sixteen when Grace McKee married her off to a neighbor, Jim Dougherty. The celebration took place on June 19, in Brentwood, in Los Angeles.

1943: Eighteen months after they were married, Jim, who had signed for one year in the merchant navy, embarked onboard the Julia S. Dumont, headed for the Pacific.

1944: Norma Jean, bored, found a job with the Radioplane Company, where she inspected parachutes. David Conover, on assignment to take pictures for the army, told her she should be on magazine covers.

1945: After a meeting at the Blue Book Agency, Norma Jean was hired as a model by André de Dienes.

1946-1948: Her first photo shoot resulted in a cover for *Family Circle*. She started up divorce proceedings and decided to change her name. The same year, she met Bernard of Hollywood, who had her sign a contract with Fox, but she only made brief appearances in films like *Scudda-Hoo! Scudda-Hay!* (1948) and *Love Happy* (1950).

1949: Her career was going nowhere and the actress, in need of money, posed nude for Tom Kelley.

1950: Her true career started when the photographer Sam Shaw presented her to John Huston, who immediately gave her a part in his movie *Asphalt Jungle*, her first true film role. She then acted alongside Betty Davis in *All About Eve*.

1952: The nude photographs by Tom Kelley, published in a censored calendar called "Miss Golden Dreams," caused a scandal and threatened her career. Fox considered breaking her contract, but Marilyn was able to turn the situation to her advantage. The cover of *Life* magazine ensured her glory on April 7. The photographer Jock Carroll covered the filming of the movie that confirmed the star's success: *Niagara*.

1952: After her second major role, in *Gentlemen Prefer Blondes*, she left her hand and footprints on the fresh cement of Hollywood Boulevard. She met Joe DiMaggio in February, and they started dating.

The Mood: *in this photo, Marilyn is wearing the same dress she wore in* Gentlemen Prefer Blondes, *circa 1953.*
© *Courtesy Susan Bernard/Bernard of Hollywood Publishing/Renaissance Road Productions Inc.*

1953: At the end of the summer, she met Milton Greene, who convinced her to break with Fox and start up her own company: Marilyn Monroe Productions (MMP). The same year, she posed for the famous photographer Richard Avedon.

1954: On January 14, her marriage with the former baseball player Joe DiMaggio made the front page of newspapers the world over. On February 16, in the middle of their honeymoon, she left for four days to entertain American soldiers fighting in Korea. In May, the filming of *There's No Business Like Show Business* started. Marilyn started having health troubles due to prolonged use of sleeping pills. She followed up however with *The Seven Year Itch*. The scene shot at the metro entrance was instantly world famous. By the end of the year, her marriage had disintegrated.

1955: Marilyn went to The Actors Studio hoping to become a confirmed actress. She had an affair with Arthur Miller.

1956: With Milton Greene, she produced *Bus Stop* and *The Prince and the Showgirl*. On June 29, she married Arthur Miller.

1957: Arthur Miller decided to take charge of her career, and Marilyn terminated her collaboration with Milton Green, after more than fifty photo shoots. She then worked with several renowned photographers, including Eve Arnold, Cecil Beaton and Richard Avedon.

1958: After a two-year absence, Marilyn returned to Hollywood for the filming of *Some Like it Hot* with Jack Lemmon and Tony Curtis. Her health continued to deteriorate. She starred alongside Yves Montand in a mediocre film called *Let's Make Love*.

1960: Filming of *The Misfits* started in July, adapted from a short story by Arthur Miller and directed by John Huston. This legendary film stars Marilyn alongside Clark Gable and Montgomery Clift.

1961: In January, when *The Misfits* was released, Marilyn divorced Arthur Miller. She bought a house in Brentwood.

1962: The filming of *Something's Got to Give* started in April but the film was never finished. On May 19, Marilyn sang "Happy Birthday" to President Kennedy during a Democratic Fundraiser held at Madison Square Garden. From May to August, she posed for numerous photographers, including James Mitchell, Larry Schiller, George Barris and Bert Stern. Marilyn died on the night of August 4 in her home in Brentwood.

Sale at Christie's (October 1999); dress that Marilyn wore for President Kennedy's birthday.
© Photo: Kenji Toma/Christie's.

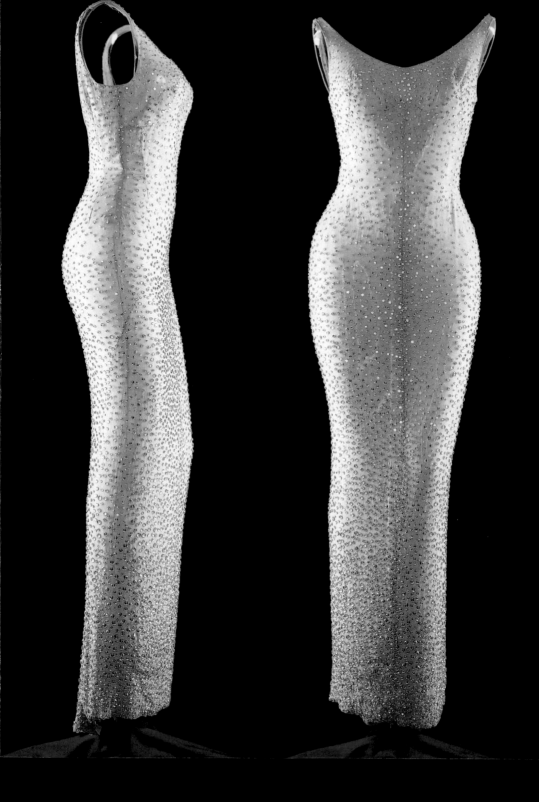

Marilyn

Portrait of Marilyn in the early days. © J.R. Eyerman/*Life Magazine*/Time Warner Inc./PPCM.
Marilyn arrives in Korea on February 17, 1954 to entertain American troops. She was in the middle of her honeymoon with her second husband, Joe DiMaggio. © The Kobal Collection/PPCM.

With her dramatic art professor in 1949. © 1949 J.R. Eyerman/*Life Magazine*/Time Inc./PPCM.
Portrait of a star in 1954. During their photo shoots, Marilyn and Milton Greene loved to work photos to perfection. © 1999 Archives of Milton H. Greene, LLC.

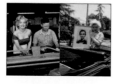

Black Lace, **photo taken from** *The Glamour Series,* **circa 1952.** Bernard of Hollywood photographed the crucial moments of Marilyn's life. He declared that she had developed a sixth sense, a "photogene." © Courtesy Susan Bernard/Bernard of Hollywood Publishing/Renaissance Road Productions, Inc.

Break during the filming of *Niagara,* the actress is photographed on an assembly line © Photo: Jock Carroll/Time Inc./PPCM.
America: Marilyn poses with a portrait of Abraham Lincoln, her idol, in her Cadillac convertible. © 1999 Archives of Milton H. Greene, LLC.

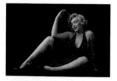

Final photo shoot with Milton Greene in January 1957. The "red dress" series reveals the mischievous, erotic charmer, at one with the camera. © 1999 Archives of Milton H. Greene, LLC.

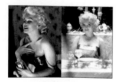

At the Ambassador in New York. Marilyn puts on Chanel N°5 before the premiere of the movie *Cat on a Hot Tin Roof* in 1955. © Photo Ed Feingersh/Michael Ochs Archives/PPCM.
Banquet at the El Morrocco in 1955. © Michael Ochs Archives/PPCM.

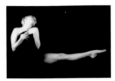

"Let's do a Marilyn," she liked to say during a photo shoot. Her last photo shoot with Milton Greene, called "Black Sitting," reveals the perfection of the model and the photographer. © 1999 Archives of Milton H. Greene, LLC.

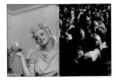

With a drink in hand, 1955. © Photo Ed Feingersh/Michael Ochs Archives/PPCM.
Paris Ball at the Waldorf Astoria in New York. The star waltzes in the arms of her third husband, the playwright Arthur Miller. © Photo: Peter Stockpole/Life Magazine/Time Warner Inc./PPCM.

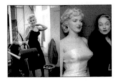

Intimate scene. Milton Greene often photographed Marilyn without telling her, like here at Fanton Hill © 1999 Archives of Milton H. Greene, LLC.
Meeting of two legends. Marilyn Monroe and Marlene Dietrich during the press conference announcing the formation of the Marilyn Monroe Production on January 7, 1955. © 1999 Archives of Milton H. Greene, LLC.

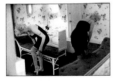

Getting ready: In the privacy of her room at the *Ambassador* in 1955. Ed Feingersh reveals a very sensual Marilyn, getting dressed for the premiere of the film *Cat on a Hot Tin Roof.* © Photo Ed Feingersh/Michael Ochs Archives/PPCM.

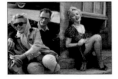

With Arthur Miller in a convertible in 1955. They just met. © Photo: Paul Schutzer/ *Life Magazine*/Time Warner Inc./PPCM.
Taking a walk through the outdoor sets at Fox Studios: Marilyn is dressed for her role in *Bus Stop.* © 1999 Archives of Milton H. Greene, LLC.

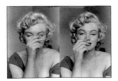

During the filming of *Niagara* **in 1952.** Marilyn would smoke during the breaks in her room at the General Black Motel. These photos weren't published until 1996. © Photo: Jock Carroll/Time Inc./PPCM.

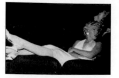

Wearing the famous "metro scene" dress, which has become a Hollywood symbol, Marilyn is relaxing in the projection room at Fox, during the filming of *The Seven Year Itch.* © Courtesy of Susan Bernard/Bernard of Hollywood Publishing/ Renaissance Road Productions, Inc.

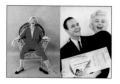

Complicity: More than any other great star, the photographers who entered her life became close friends. A model both ideal and idealized, she was photographed in her personal life and on stage, especially by Milton Greene, who was able to get from her unforgettable, timeless images. © 1999 Archives of Milton H. Greene, LLC.

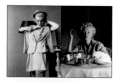

That famous smile: With Marlon Brando during the Actors Studio party at the hotel *Astoria* in New York on December 12, 1955, during a photo shoot. Marilyn's famous laugh is known universally. © 1999 Archives of Milton H. Greene, LLC.

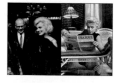

During the filming of *Niagara:* Marilyn chooses her outfits. © Photo: Jock Carroll/ Time Inc./PPCM.
Having breakfast in the privacy of her suite in New York in September 1954. © 1999 Archives of Milton H. Greene, LLC.

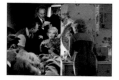

Actors Ball on March 14, 1961. © Bob Gomel/*Life Magazine*/Time Inc./PPCM.
Reading the *Motion Picture Daily Newspaper,* at the time of her dispute with 20th Century Fox, in 1955. © Michael Ochs Archives/PPCM.

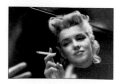

Makeup and hairstylist session. © Photo: John Bryson/*Life Magazine*/Time Inc./ PPCM.
Final makeup touches. Marilyn is preparing for the projection of *Cat on a Hot Tin Roof* in 1955. © Photo Ed Feingersh/Michael Ochs Archives/PPCM.

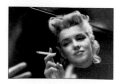

Restraint: Ed Feingersh enjoyed surprising Marilyn in her attitudes of everyday living. This picture was taken during a break in Costello in 1955. © Photo Ed Feingersh/ 1988 Archives Alive, Ltd./PPCM.

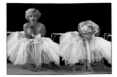

One of Marilyn's most famous photo shoots, by Milton Greene, was inspired by this poorly arranged white dress. This series of pictures was taken in the Lexington Avenue studios in New York in September 1954. © 1999 Archives of Milton H. Greene, LLC.

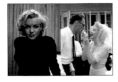

The day after her thirtieth birthday, Marilyn arrives at the Idlewild airport in New York, accompanied by Milton Greene, after the filming of *Bus Stop*. © Photo: UPI/ 1999 Archives of Milton H. Greene, LLC.
"Happy Birthday Mr. President . . ." Marilyn Monroe sings for John Fitzgerald Kennedy on May 19, 1962 at Madison Square Garden during the Democratic Fundraiser. © Photo Bill Ray/*Life Magazine*/Time Inc./PPCM.

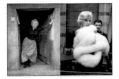

Photo taken from the book *Witness of our Time*, 1950. © Photo: Alfred Eisenstaedt/*Life Magazine*/Time Inc./PPCM.
Wedding with the playwright Arthur Miller. The ceremony was held at the home of her agent, Kay Brown, in northern New York. © 1999 Archives of Milton H. Greene, LLC.

The anti-star, when seen from the outside. The actress is dressed in the costume of Jennifer Jones in *Song of Bernadette*. © 1999 Archives of Milton H. Greene, LLC.
Making her entrance at the Hotel *Astoria* in New York, on December 12, 1955, during a benefit party organized by the Actors Studio. © 1999 Archives of Milton H. Greene, LLC.

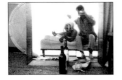

New York, 1955. © Photo Ed Feingersh/Michael Ochs Archives/PPCM.
Stolen image: taking off a shoe on the set of *Niagara*. © Photo: Jock Carroll/Time Inc./PPCM.

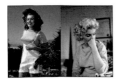

Summer of 1962: the last photo shoot. Behind the bottles of champagne, the mirror reflects an image of a very happy Marilyn alongside Bert Stern. This legendary photo shoot took place in Bungalow 96 of the Hotel Bel-Air in Los Angeles before the tragic death of the star. © Photo: Bert Stern.

In 1945, Marilyn was only 19 years old. She was but a fledgling model. This portrait by George Zeno reveals her photogenic nature. © Photo: George Zeno/The Kobal Collection/PPCM.
In 1955, ten years later, the zenith of a star. One of the rare photos of Marilyn where she is not showing off her legendary smile. © Photo Ed Feingersh/Michael Ochs Archives/PPCM.

The editor wishes to thank Susan Bernard, John Bryson, Bob Gomel, Joshua Greene, Bert Stern, Kenji Toma, George Zeno, as well as *Life*, Michael Ochs Archives, UPI and the Kobal Collection for their help in creating this book.
We also wish to thank Christie's New York, Jean-Christophe Chéreau (PPCM), Sonni Strenke (The Archives of Milton H. Greene) and David Wallis (Bernard of Hollywood Publishing) for their kind collaboration.